THE FIRST WORLD WAR IN PHOTOGRAPHS

JOHN CHRISTOPHER & CAMPBELL MCCUTCHEON

AMBERLEY

First published 2014

Amberley Publishing
The Hill, Stroud
Gloucestershire, GL5 4EP

www.amberley-books.com

British Library Cataloguing in Publication Data.
A catalogue record for this book is available from the British Library.

ISBN 978 1 4456 2181 4 (print)
ISBN 978 1 4456 2196 8 (ebook)

Typeset in 11pt on 15pt Sabon.
Typesetting and Origination by Amberley Publishing.
Printed in the UK.

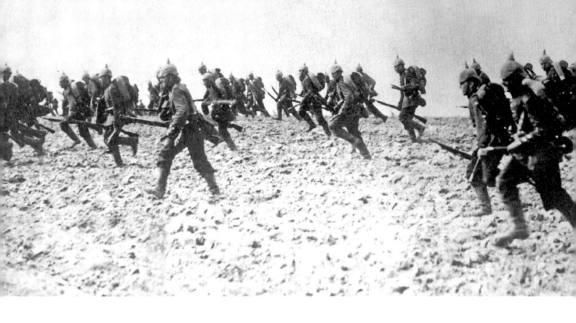

Contents

Introduction 5

August 1914 25

September 1914 92

October 1914 111

November 1914 123

December 1914 135

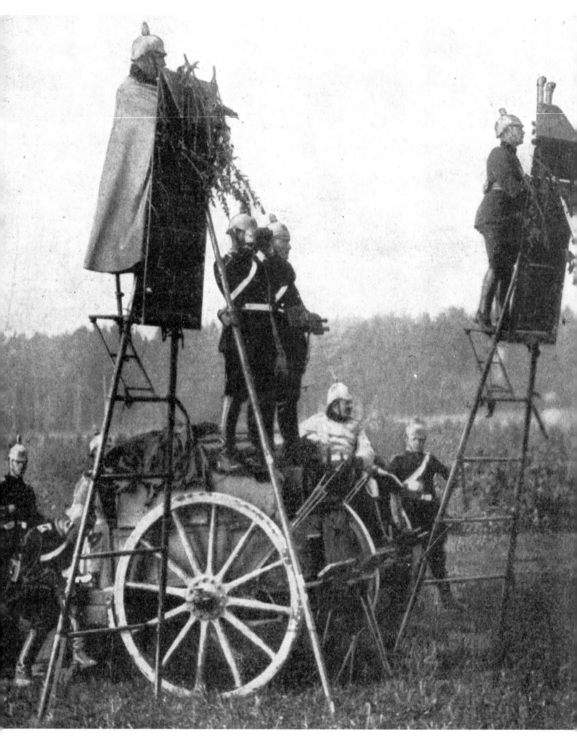

On the eve of war, German officers stand atop scantily camouflaged 'observation ladders'. Such bravado, and the uniforms of former era, will be swept away in the onslaught of the first industrialised conflict.

Introduction

The last two decades of the nineteenth century were ones of rampant expansion of Europe's superpowers. They saw the joining together of the various German states to become a unified Germany as well as the rise in power of the British and the Austro-Hungarian empires. The industrialisation of Europe saw developments in weapons and in the ability to move people, and therefore troops, quickly as well as provide the economic growth that helped fund the costs of each country's imperialist ambitions. The unification of Germany also saw a naval arms race like no other. From 1897 onwards, when Kaiser Wilhelm II saw the 168 vessels of the British fleet at the Diamond Jubilee Review at Spithead, both the German merchant and naval fleets saw a huge expansion. The UK was already the dominant sea power and did not want to see its position eroded. It was a case of keep up or lose command of the seas. In the age before aeroplanes, ships mattered.

The Kaiser had been furious that his paltry naval ships in attendance at Spithead were dwarfed by those not just of Britain, but of the USA and Russia too. He had witnessed from the deck of his royal yacht a British fleet that stretched thirty miles down the Solent. He had witnessed, too, the very first turbine steamer, a British invention, steamed up and down at 30 knots past the fleet. It was all of this that made him decide Germany too would have such a navy, as powerful as the British, and that Germany too would be a major sea power as well as a major land power.

Within weeks of Spithead, Wilhelm II had promoted Admiral Alfred von Tirpitz as Secretary of State for the German Navy. Quickly, a plan was put together, now known as the Tirpitz Plan, to oversee a huge growth in the number and size of ships, and to create a navy so powerful that the Royal Navy would not want to fight it. After all, ships were hugely expensive and no one wanted to lose one.

This was the first twentieth century cold war, a period dedicated to war-mongering but without actually declaring hostilities. Britain's navy was spread throughout the world, defending British interests in Asia, Africa and the Americas, and Tirpitz surmised that the German navy need not be so big, just powerful enough to counter any British threats to it. His High Seas Fleet would be strong enough to simply prevent Britain's navy wanting to engage it. The first of many Acts passed through the German government in 1898, and soon the shipyards of Kiel, Bremerhaven, Stettin and Hamburg were busy with work, building not only battleships but also merchant ships. That period from 1900 onwards saw

a series of German merchant vessels built that could compare with the best of Harland & Wolff or John Brown's and the fleets of Hamburg Amerika and North German Lloyd dominated the Atlantic, winning the Blue Riband for Germany for the first time and with ships more opulent and luxurious than anything White Star or Cunard could offer.

With this huge German fleet under construction and all within hours of Britain's East Coast, it was obvious Britain would have to compete. Admiral Jacky Fisher, the First Sea Lord, had decided Britain needed a fleet twice as large as Germany's within proximity to the North Sea. His forceful opinion that Britain needed a navy that was at least the size of the next two largest navies combined became accepted policy and Britain was soon building ships as fast as the shipyards could launch them.

At the same time, Germany's army was on a war footing too. That of Austro-Hungary was also being built up. Britain's army relied on highly trained and motivated regular soldiers, while the European armies relied on conscription, with many men having to do compulsory military service. One policy gave a motivated but small army which was well trained while the alternative offered a vast group of men who had been trained militarily but were perhaps much less dedicated. With

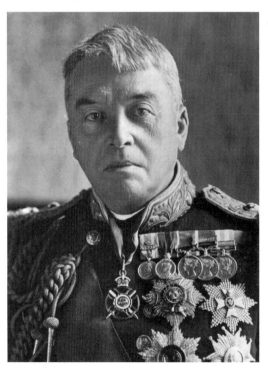 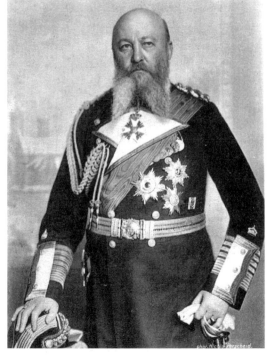

Left: Admiral Lord Jackie Fisher was responsible for the building up of Britain's fleet of Dreadnoughts, named after the first of the modern battleships. *Right:* After the 1897 British Naval review, Admiral Alfred von Tirpitz was put in command of the German navy's expansion. He oversaw the building-up of the German fleet to a two-thirds parity with the Royal Navy.

the expansion of their empires, particularly in Africa, the European nations used their troops to protect their borders but also for this growth of their colonies. Each imperialist expansion saw elements of gunboat diplomacy, with the British and French nearly clashing in Sudan in 1898, and, in 1911, the French and Germans almost coming to blows over parts of Morocco. With their territorial ambitions and a military build up on the Continent and in Britain, war was almost inevitable.

In 1906, Britain launched a new battleship, the *Dreadnought*. Massively heavily armed with ten 12in guns, armour plate and a top speed of 21.6 knots, she was more powerful than any ship afloat. The British turbine technology powered *Dreadnought* too. She was simply unbeatable. But Kaiser Wilhelm had decided that if Britain had *Dreadnought*, Germany would build similar, and so the arms race continued.

Dreadnought – the first modern battleship

The father of *Dreadnought* was Admiral Jacky Fisher, who had asked soon after taking office for designs for a battleship with a top speed of 21 knots and armed mainly with 12-inch guns. At 18,120 tons she was also among the largest naval ships afloat. With a length of 570 feet and a breadth of 82 feet 1 inch, and with five turrets of two 12in guns, she was simply revolutionary. Everything from her power plant to her armour was new. She was simply unbeatable. America was soon building Dreadnoughts and Germany was too.

In 1905, *Dreadnought* had been laid down at Portsmouth and construction began. With three-bladed propellers and eighteen Babcock & Wilcox boilers powering her four turbines, she was faster than any battleship afloat, as well as better armoured and better gunned. With a range of some 6,620 miles she could travel the Atlantic and back without refueling. She had electric range-finding equipment and was amazingly accurate for the time, with a range of over 13,000 yards. Her armour was German, however, mainly Krupp cemented armour.

With plans to have her built within a year, Fisher had stockpiled much of the steel required for her construction, as well as ordered boilers and engines. On 2 October 1905, she was laid down and on 10 February 1906, she was launched by King Edward VII. It took four attempts to shatter the bottle of Australian wine used to name her. On 3 October 1906, she left on her sea trials and entered service on 11 December 1906, at a cost of £1,783,883. Her first voyage was to the Mediterranean and then she sailed for Trinidad in January 1907. Averaging 17 knots, she proved to be as good in real life as she was on paper. Returning to the UK, she became flagship for the Home Fleet and participated in the 1911 Coronation review.

As well as an expansion in new ships there was an expansion of naval bases too. For centuries the dominant threat to the UK had been from France and Spain. Now it was from Germany and the defences along the South Coast were no longer as important. New naval bases, protecting the North Sea and the approaches to it

from the Atlantic, were hastily built. Germany expanded its bases at Heligoland and at Kiel. The Kiel Canal had already given an easy access from the Baltic to the North Sea for the German fleet.

In 1908–09 German Dreadnought construction outpaced Britain's by seven to four. Britain's plans for just four Dreadnoughts in 1910–12 saw public outrage. Demonstrations saw the cry of 'We want eight and we won't wait' heard outside the Admiralty. The public got their way and eight were ordered. In 1911, five Dreadnoughts were building. By 1913, as Britain was raising its number, German battleship construction was slowing down.

Both Britain and Germany were spending huge sums on their navies and it could not continue. The army had to be considered too. On land, things were changing too. Mechanisation, new weapons and new threats were all becoming rather important as the politics of Europe were taking a turn for the worse. In 1914, Germany finally reached its two-thirds parity with Britain, having nineteen Dreadnoughts to Britain's twenty-nine.

In Britain, however, the desire to produce Dreadnoughts had caused a lack of investment in and new building of smaller naval vessels and many of the cruisers and destroyers were woefully inadequate for modern service. Germany had not ignored its smaller vessels and the German fleet was much more modern than Britain's, and, more importantly, the Germans had seen the advantage of submarines and had started construction of fleets of them too.

Militarily, the major nations of Europe, Russia, France, Germany and Austro-Hungary, were preparing for war. The arms race could lead only one place, and with a militaristic regime in Germany, the other nations of Europe had to keep up. Along their borders, the peaceful Belgians built forts, as had the Germans and French. Politically, countries allied themselves with neighbours and other nations. France was allied to Britain and Russia, Germany with the ethnically-diverse Austro-Hungarian Empire and numerous smaller countries allied themselves with one or other of these factions. In the Balkans, both Russia and Austro-Hungary eyed the spoils of what was a splintering Turkish empire. Serbia would be the flashpoint of the war although the events that started the chain reaction took place in Sarajevo, Bosnia, when Gavrilo Princip, a Bosnian Serb, assassinated Archduke Franz Ferdinand on 28 June 1914. Within the month, Austro-Hungary had made an ultimatum to the Serbs. Ten demands are made and Serbia agrees to nine, while mobilising her armed forces at the same time. Austro-Hungary refuses this compromise and declares war on Serbia on 28 July. Russia comes down on the side of the Serbs, while Germany supports the Austro-Hungarians. Britain mobilises and orders its naval vessels to their war bases. On 29 July, the first shots are fired by the Austro-Hungarian navy against Belgrade. The war had begun and it was expected to be a short one.

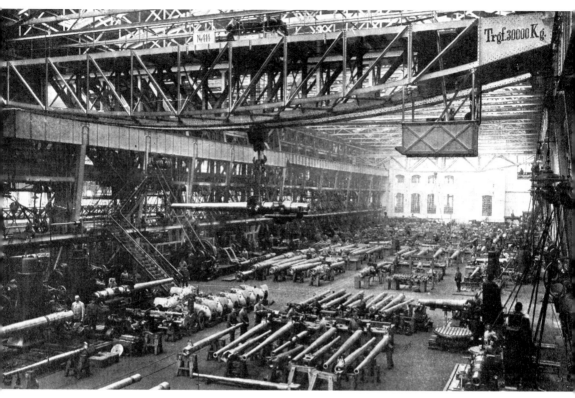

Above: Inside Krupp's works at Essen. This is one of the largest workshops devoted to the manufacture of large guns.

Hostilities Commence

With the assassination of Archduke Franz Ferdinand in Sarajevo, the fate of Europe was decided. In a series of political machinations, country after country declared war against each other. At the end of July, the German fleet was recalled from its Norwegian exercises and on 1 August, the British Battle Fleets were ordered to war stations. On 4 August 1914, war was declared between Britain and Germany. Admiral Sir John Jellicoe was made commander of the Grand Fleet. A blockade was made against German shipping, from the Dover Patrol in the Channel to the Grand Fleet in the North Sea. Ships were stopped, prizes taken and contraband in neutral ships confiscated. German merchant ships at sea were quickly converted into armed merchant cruisers or made mercy dashes for neutral and home ports. Even the *Mauretania*, the world's fastest ship, made for Halifax, Nova Scotia, before a high speed dash across the Atlantic to Liverpool. Germany's *Kronprinzessin Cecile* was interred at Bar Harbor in Maine, and the port of Falmouth soon filled with prizes of war.

Germany declares war on neutral Belgium on 4 August. The coalfields of Belgium would be an excellent addition to German resources, but, more importantly, the

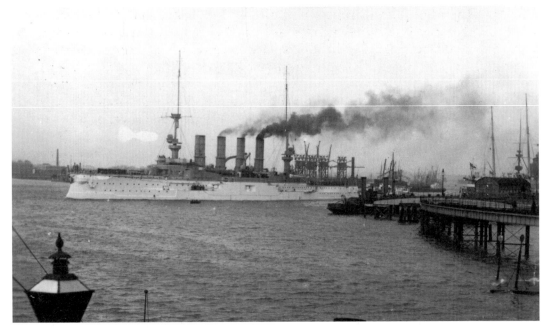

Prior to the war, the fleets of both Britain and Germany made many courtesy calls to each other's harbours, no doubt noting defences and developments in naval architecture. *Above:* The German cruiser *Sharnhorst* visits Portsmouth in 1908. *Below:* The British fleet in Kiel in June 1914, soon before war started.

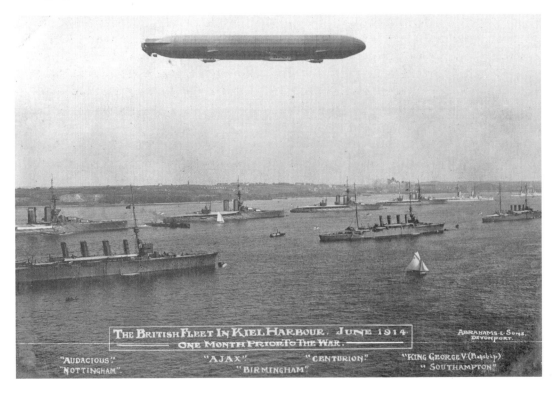

THE BRITISH FLEET IN KIEL HARBOUR. JUNE 1914.
ONE MONTH PRIOR TO THE WAR.
ABRAHAMS & SONS. DEVONPORT.

"AUDACIOUS". "AJAX" "CENTURION" "KING GEORGE V (Flagship)"
"NOTTINGHAM". "BIRMINGHAM" " SOUTHAMPTON"

German army needs to cross Belgium to take northern France and open the route to Paris. The Schlieffen Plan, as it was known, would see the Germans attack on a front that extended from Belgium to Luxembourg. The plan would be to knock France out before it mobilised, while turning on Russia after the French had capitulated.

On the first day of war, the German battleship *Goeben* and the cruiser *Breslau* are detected by HMS *Gloucester*, using radio transmissions to find them. The ships ran for Constantinople, shelling Bone and Philippeville on the way. France was at war but Britain wasn't yet so when spotted by *Indomitable* and *Indefatigable* they let them pass. Soon the two German ships had slipped into the Dardanelles and headed for Constantinople. The two German ships were quickly 'sold' to the Turks. No one was fooled by the German crew in Turkish uniforms but as Turkey was neutral nothing could be done.

The first British shots of the war are fired on the 5th by the destroyer *Lance*, which sinks the German minelayer *Königin Luise* in the Thames estuary. The next day sees the first British casualty when the cruiser *Amphion* is sunk by one of *Königin Luise*'s mines. Her captain orders 'Abandon Ship' but she hits another mine before finally sinking, taking nineteen German survivors of the *Königin Luise* to the bottom.

A day later, but a world away in the West Indies, the cruiser *Suffolk* comes upon the cruiser *Karlsruhe* and the liner *Kronprinz Wilhelm* transferring guns and supplies. The *Kronprinz Wilhelm* had been built to be converted into an armed merchant cruiser and the guns were destined for her. *Suffolk* quickly begins the chase of *Karlsruhe* but loses the faster German vessel. 100 miles north of the Orkneys, on the 9th, the light cruiser *Birmingham* sinks the first U-Boat of the war, the U-15. On the 26th, after a short chase, the armed merchant cruiser *Kaiser Wilhelm der Grosse*, once Germany's fastest merchant vessel and the first of the fifteen four-funneled liners built, is cornered by HMS *Highflyer* off the west coast of Africa. The German ship is attacked and within an hour is on her side and sinking. Ninety of her crew reach shore before she goes to the bottom. She is the first armed merchant cruiser of the war to be lost to enemy action.

On land, war continued apace. British troops are mobilised for the defence of Belgium, while Serbia declares war on Germany on 6 August. On the 8th, Lord Kitchener calls for 100,000 volunteers to take arms against Germany, which had violated Belgian neutrality. By 10 August, Liège's first forts have fallen to the Germans and on 12 August, Britain declares war on Austro-Hungary. On 14 August, H. G. Wells calls the conflict, 'The war to end all wars'. Between 14–22 August the French, as expected by the Germans, attack Alsace-Lorraine, which they had lost in the Franco-Prussian War. On 16 August, Liège surrenders. The next day, the Russians invade East Prussia. The next day, in a fast-moving conflict, the Belgian army retreats to Antwerp and, on the 19th, the German army shoots 150 civilians at Aerschot. Brussels is occupied on the 20th while fighting continues in East Prussia. The Cameroons are invaded by the British, with some 400 troops and the German High Command authorisea the use of airships against London and other British targets.

In the Ardennes, the French army is almost wiped out in fierce fighting with the Germans and the French falls back to a defensive line along the rivers Meuse and Marne. On 23 August, the Japanese declare war against Germany and Austro-Hungary. Their target is clearly the German treaty ports in China, including Tsingtao. The Battle of Mons takes place too, with the British Expeditionary Force taking part for the first time. Despite their accurate fire, the British have to withdraw, making an orderly retreat. Some 300,000 French casualties have been killed or wounded in the first clashes of the war. The Austro-Hungarians attack Russian-controlled Poland on 23 August, creating a diversion for the Germans fighting in East Prussia. In the Battle of Tannenberg, the Germans capture almost 100,000 Russians. In Togoland, on 26 August, the British and French capture the colony from the Germans.

On 28 August, the British battlecruisers *Invincible*, *Lion*, *New Zealand*, *Princess Royal* and *Queen Mary*, under Admiral David Beatty, attack a German fleet in what would become the Battle of the Heligoland Bight. A light cruiser force has left Harwich to force the Germans into action. The plan works and the German force is ambushed with the loss of three cruisers, the *Ariadne*, *Köln* and *Mainz*, and a destroyer. With just thirty-five casualties, the British fleet takes 1,000 prisoners.

On 30 August, Paris is bombed from the air, making it the first capital city to be attacked this way. A German Taube fighter drops four small bombs as well as propaganda leaflets.

Disaster befalls the Austro-Hungarian forces in Galicia and it becomes obvious they cannot fight a modern war without German help. In September comes the first loss to a U-Boat of the war when HMS *Pathfinder* is sunk by U-21 off the Isle of May on the 5th. Eight days later, Lt-Cmdr Max Horton in E9 sinks the German cruiser *Hela* off Heligoland. Horton would go onto great success as a submarine captain. Also on the 5th, the British and French counter-attack along the Marne. The first battle here is known as the Battle of the Ourcq and it causes a gap to open between Kluck's First Army and von Bülow's Second Army, which the British exploit. On the 9th, the Germans begin to withdraw after suffering heavy casualties. It is this defeat that ultimately leads to the failure of the Schlieffen plan. The failure to capture Paris and knock out the French will have disastrous consequences for tens of millions of men, women and children in Europe. With this defeat comes the prospect of the Germans fighting on two fronts. With Antwerp under attack, King Albert of the Belgians counterattacks, causing the Germans to bring more soldiers and artillery to the city. British naval forces also take part in the defence of Antwerp. A German army, after soundly defeating the Russians, is rushed to Silesia to help the Austro-Hungarians on 17 September.

On 19 September, the German cruiser *Königsberg*, which has been hiding in the Rufiji Delta, decides to attack. Her port of call is Zanzibar, where she sinks HMS *Pegasus*.

The 22nd sees the SMS *Emden* begin her war career proper in the Indian Ocean, when she bombards the oil refinery at Madras. She will sink many vessels before being caught by HMS *Sydney*. Britain's major defeat of the early war is to come

on the 22nd, when the *Aboukir*, *Hogue* and *Cressy*, three rather old and outdated cruisers, are sunk by the U-9. The neglect of the smaller cruisers and the emphasis on Dreadnoughts was to cost dear that day: 1,459 sailors died. *Aboukir* is hit first and the two other ships are torpedoed while attempting to rescue survivors.

October sees the Royal Naval Division take part in the final defence of Antwerp and the Royal Naval Air Service attack the Zeppelin hangars at Düsseldorf on the 8th. Seven days later HMS *Hawke* is sunk by U-9. The first Canadian troops arrive in Plymouth on 13 October while on the 17th, the light cruiser *Undaunted* and four destroyers saink four German destroyers off Texel. New Zealand troops leave Wellington for Britain on 16 October, and the next day, some 20,000 Australian troops leave for the UK too. Parts of low-lying Belgium are flooded to prevent the Germans advancing. War in the Middle East starts with the invasion of Mesopotamia by British Indian troops on 23 October. The Turks are finally forced out of Basra on 23 November.

The heavily gunned but lightly built monitors *Humber*, *Severn* and *Mersey* are used to bombard the Belgian coast on the 18th and the next day sees the E9 lost to a U-boat and on the 20th the first British merchant ship of the war lost to a submarine is the *Glitra*, sunk by U-17. Mined on the next day is the virtually brand-new Dreadnought HMS *Audacious*. She is mortally wounded and, despite efforts to tow her to safety, blows up and sinks at 11.00 p.m. that night. The Admiralty tries to pretend she had not been sunk but many Americans had been aboard the White Star liner *Olympic*, which had spent much of the early evening rescuing her crew. The end of October sees the discovery of the *Königsberg* in the Rufuji Delta and attempts are made to flush her out.

Between 29 October and 24 November heavy fighting around Ypres ends in stalemate and the troops begin to dig in for a long war, with trenches ultimately being constructed between the North Sea and the Swiss border.

November sees the search for the East Asiatic Squadron of Admiral Von Spee. The light cruiser HMS *Glasgow* and two rather old cruisers, the *Monmouth* and *Good Hope*, along with the Orient Line's *Otranto*, converted to a lightly defended armed merchant cruiser, began the search. They are soon joined by the pre-Dreadnought HMS *Canopus*, which is slow and had never fired a gun in anger. On the 1st, the two fleets meet at Coronel, Chile. Within the hour, the two older cruisers are gone, lost with all hands, and with no damage to the German fleet at all. Britain has suffered its first naval defeat in a century, and with the loss of two entire crews too.

Russia declares war on Turkey on 2 November and invades Turkish-held Armenia. The Turks repulse the attack on 11 November. On the 3rd, in East Africa, the British fail to capture German-held Tanga. In Britain, the Norfolk and Suffolk coast is bombarded by the Germans on 3 November while on the 7th, von Spee's base at Tsingtao is captured. That same day Turkey declares war on little Belgium. Two days later, more good news for the Allies comes when the *Emden* is sunk by HMS *Sydney*. She has been cornered while attempting to shell the wireless station on the Cocos Islands. *Emden* has been responsible for the loss of almost thirty

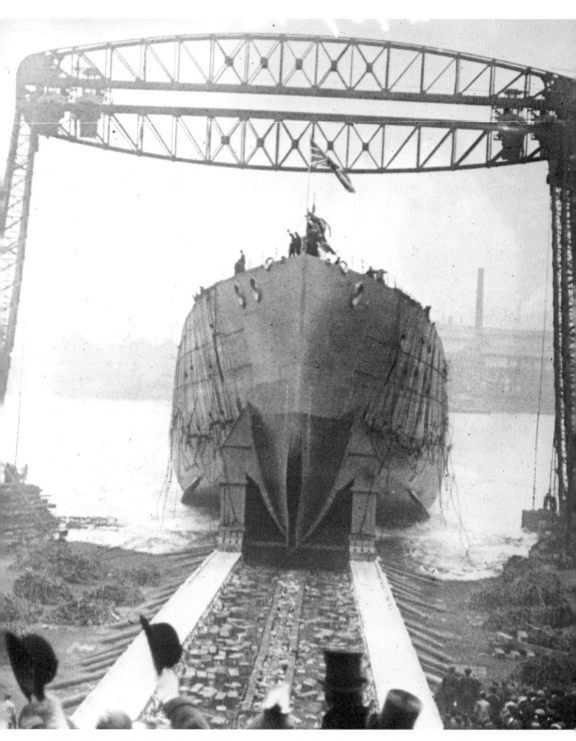

HMS *Queen Mary* being launched at Jarrow on the Tyne in 1912. This cruiser of the Lion class was completed in September 1913. With a displacement of 30,500 tons, she was armed with eight 13.5-inch guns. *Queen Mary* was lost at Jutland.

merchant ships, as well as several battleships of the French and Russian navies. The next day, plans are set in motion to sink the *Königsberg*. A collier, the *Newbridge*, is sunk across the Rufiji Estuary and the *Königsberg* is trapped. It is only a matter of time before larger British ships can come and bombard the German ship and sink her. 746 crew of HMS *Bulwark* die when she explodes at Sheerness while taking on ammunition on the 26th.

December saw *Invincible* and *Inflexible* arrive at Port Stanley on the 7th and engage von Spee's battle fleet the next day. It will be a resounding victory for the British Navy. *Scharnhorst*, *Gneisenau*, *Nürnberg* and *Leipzig* are all sunk and only the *Dresden* evades the British fleet. The first VC awarded to a submariner is given to the captain of B11, which had sneaked past Turkish minefields and sank a Turkish merchantman on 13 December. The Balkans campaign has seen some 170,000 Serbian casualties, out of an army of 400,000. The Battle of Kolubra sees the Austro-Hungarian army thrown out of Serbia. The Austro-Hungarians suffer over 50 per cent casualties, with some 230,000 dead or injured.

Admiral Hipper brings a large force of ships out on the 15th and proceeds to bombard England's east coast. From Hartlepool to Whitby and Scarborough, a huge amount of damage is caused, and it is feared that German waiters in the seaside resorts had given the German navy clues as to what to bombard. Even Whitby Abbey is hit by shells and many homes and businesses are destroyed in the Yorkshire towns. Some 120 people are killed during and after the shelling. On Christmas Day, Cuxhaven is bombed by the RNAS and the German fleet forced to disperse along the banks of the Kiel Canal. It is the last major even of the naval war of 1914.

Despite fighting in the Champagne region, the armies have dug in for a long war, and all is quiet on the Western Front. The casualty figures have a great deal to do with it and all sides need to regroup and rearm. In less than six months, over one million Britons, French and Belgians have become casualties. The German losses on the Western Front are some 675,000 with another 275,000 dead or wounded on the Eastern Front. One million Austro-Hungarians and 1.8 million Russians are also dead or wounded. 25 December, Christmas Day, sees an uneasy truce in parts of the Western Front, with German and British soldiers playing football in No Man's Land. They would go back to their trenches, realising the enemy was just like them, and dig in for the duration. The rest of the war would be a long, hard slog, in mud and difficult conditions, but for one day, the soldiers had some respite from the horrors of war.

Dreadnought simply outclassed every battleship built before her and instantly made the world's navies redundant. Her radical design saw the start of a naval race for supremacy that would see both Britain and Germany build up huge navies in the Edwardian era.

The Quarterdeck of HMS *Dreadnought* cleared for action.

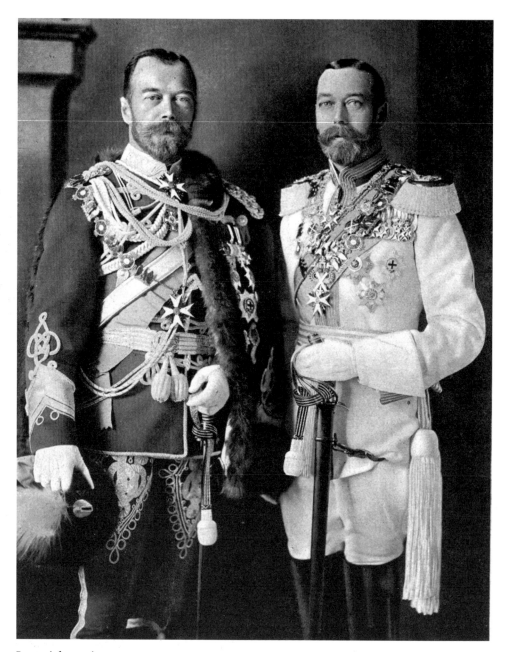

Imperial cousins

King George V, above right, was the first cousin to Tsar Nicholas II of Russia, on the left, and also to Kaiser Wilhelm II of Germany, who was the eldest grandson of Queen Victoria. With the outbreak of hostilities in 1914, the British public's loyalty to the King remained unquestioned, but these close family ties inevitably caused a degree of discomfort and H. G. Wells went so far as to refer to the Royal Family as Britain's 'alien and uninspiring court'. Even so, it wasn't until 1917 that the pressure of anti-German feelings persuaded the King to dissolve his ties with his German cousins. All German titles held by members of the Royal Family were relinquished and the House of Saxe-Coburg-Gotha became the more British-sounding House of Windsor.

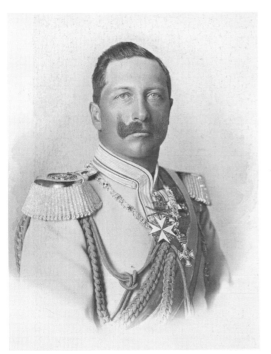

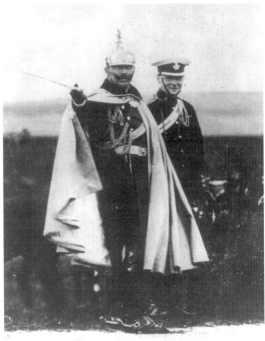

Above: An official portrait of the Kaiser and, right, with Winston Churchill at a military review before the war. *Below:* Photographs of the young heir to the British throne, Edward, Prince of Wales, in military uniform were widely featured in the magazines. *Below right:* This *Punch* cartoon, published in December 1914, is captioned, 'The King at the Front'.

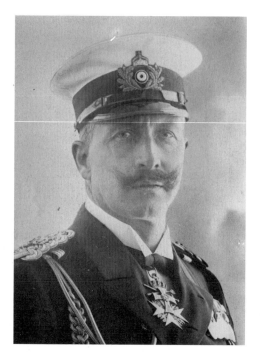
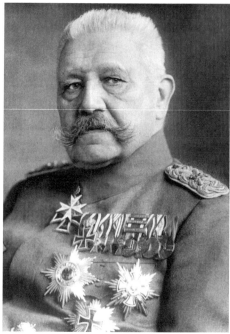

The Kaiser's chiefs

Above left: Kaiser Wilhelm in naval uniform. *Right:* General Paul von Hindenburg, the Prussian-German field marshal and statesman, had retired in 1911 but was called back to serve the Kaiser. He came to national attention through the decisive victory at the Battle of Tannenburg in August 1914, and he later became Germany's chief of staff. *Below:* Inside the German General Headquarters, Paul von Hindenburg, Kaiser Wilhelm and General Erich Ludendorff. At the start of the war, Ludendorff was appointed Deputy Chief of Staff of the army under General Karl von Bülow, who retired early, in 1916, after failing to capture Paris and through poor health.

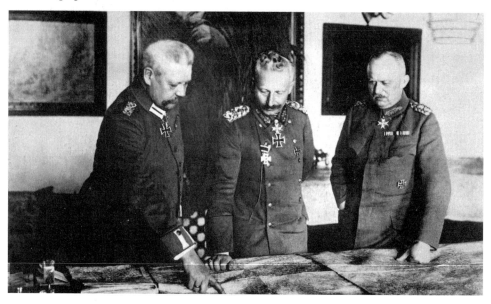

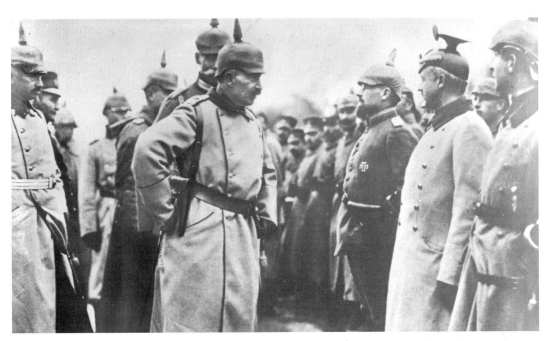

The Kaiser addresses his troops in the field, above. Note the cloth covers over the picklehaube headgear, which were intended to make it less conspicuous. The Kaiser suffered from a withered left arm and in photographs he is always shown with his hand in a pocket or holding an object. *Below left:* 'Gott mit uns', meaning 'God is with us.' This print of the Kaiser and his brotherhood include the Crown Prince, Kaiser Franz Joseph, Prince Heinrich, Graf Haeseler, Crown Prince Ruprecht von Bayern, Graf Zeppelin, Paul von Hindenburg and, lastly, the Kaiser himself. Below right; The War Minister, Alexander Freiherr von Krobatin, an Austrian field marshal and Imperial Minister for War between 1912 and 1917.

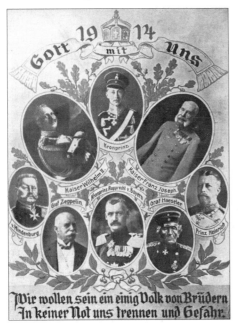

Vice Admiral Sir John Rushworth Jellicoe was promoted on 4 August 1914 to Admiral. He already had a distinguished career and was assigned commander of the Grand Fleet on the same day. He was ultimately responsible for the Navy around Britain's coasts.

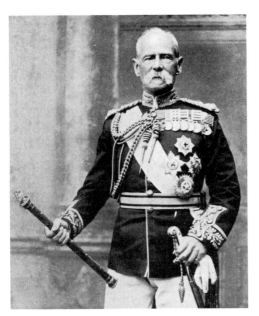
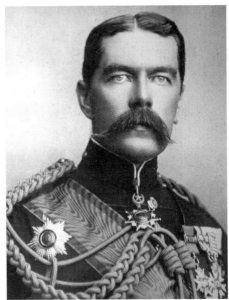

Field Marshall Earl Roberts, top right, the hero of Afghanistan and Pretoria, who died of pneumonia in November 1914 after visiting Indian troops at St Omar, France. *Top right:* Lord Kitchener, appointed Minister of war on 5 August 1914, became the face of Britain's recruiting posters – see page 44. *Below left:* General Sir John French served as the first Commander-in-Chief of the British Expeditionary Force for the first two years of the First World War before serving as Commander-in-Chief, Home Forces. *Below right:* General Sir Douglas Haig, sometimes referred to as 'Butcher Haig', the controversial Commander-in-Chief of the British Army in France and Flanders.

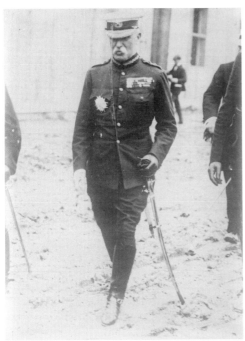
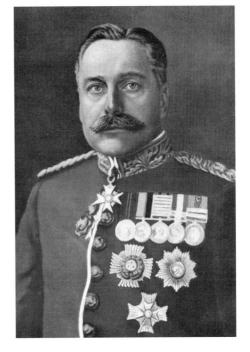

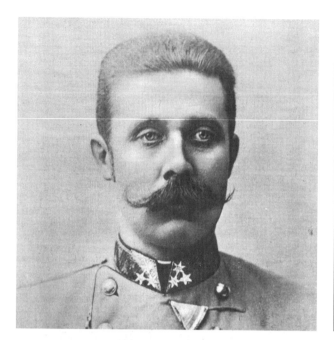

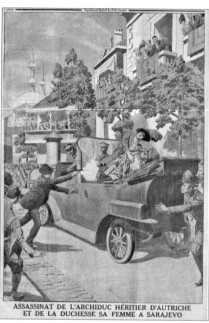

ASSASSINAT DE L'ARCHIDUC HÉRITIER D'AUTRICHE
ET DE LA DUCHESSE SA FEMME A SARAJEVO

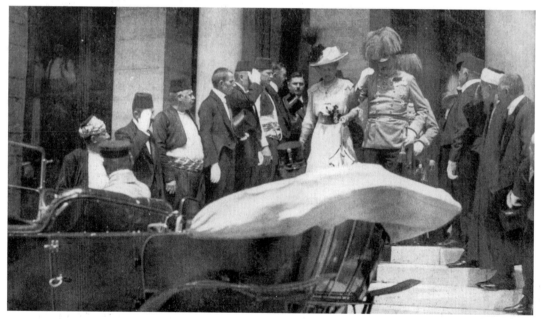

Assassination in Sarajevo

It was the spark that precipitated the war. On 28 June 1914 Archduke Franz Ferdinand of Austria and his wife Sophia had come to Sarajevo which was the capital of the Austro-Hungarian province of Bosnia and Herzegovina. Having narrowly escaped a grenade attack on their car they made an unscheduled departure from the governor's residence, and as their car was being maneuvered it temporarily stalled. A nineteen-year-old man named Gavirilo Princip, a member of the Young Bosnia movement, was on the scene and seized the opportunity to shoot both the Duke and Duchess, as graphically depicted in this illustration from a French journal, above right.

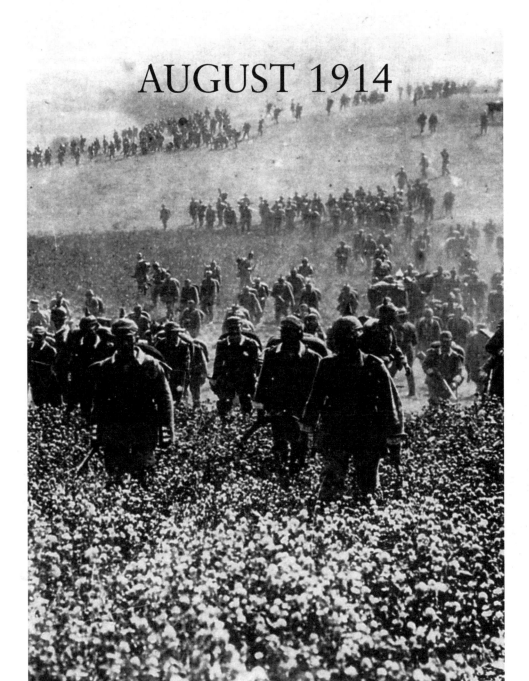

AUGUST 1914

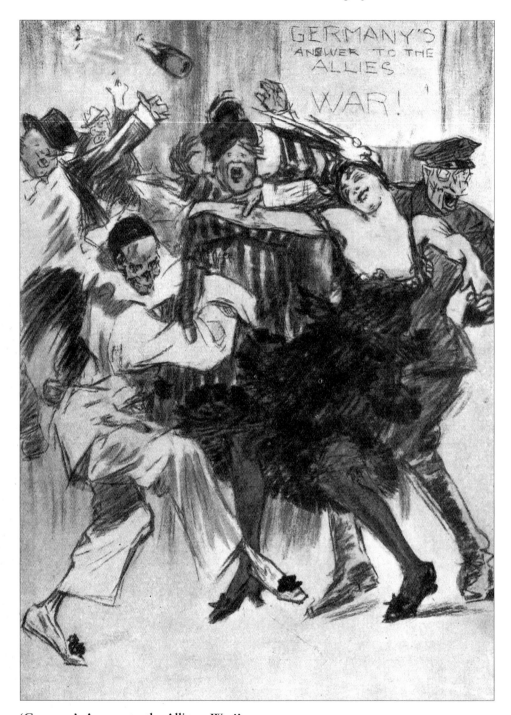

'Germany's Answer to the Allies – War!'
A Louis Raemaekers print depicting the scenes of revelry in Berlin on 5 August 1914, following the declaration of war. 'The Berlin papers declared that the population, mad with joy, drank champagne and danced in the street.' Raemaekers' cartoons invariably had a darker side and if you look closely you will see that the Pierrot figure is a skeleton, representing death.

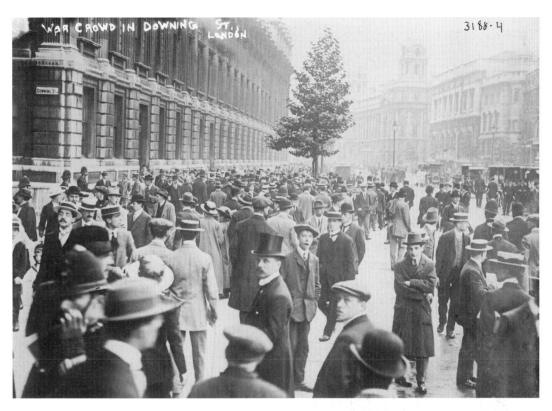

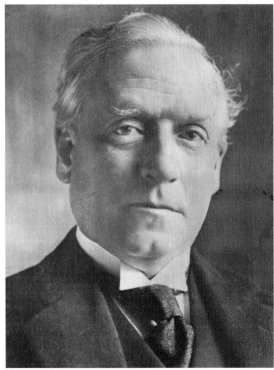

A far more pensive crowd gathers in Whitehall near the corner of Downing Street, London, to await the latest announcement. Herbert Henry Asquith, the British Prime Minister, right, asked the King to declare war on the German Empire on 4 August 1914. Asquith headed a Liberal government into the war, and although the Liberals had traditionally been peace orientated, the 1839 Treaty of London committed Britain to defend Belgium's neutrality in the event of an invasion by fellow signee, the German Confederation. Informed by the British ambassador that Britain would go to war, the German Chancellor Theobald von Bethmann Hollweg exclaimed that he could not believe that the two nations would be going to war over a mere 'scrap of paper'.

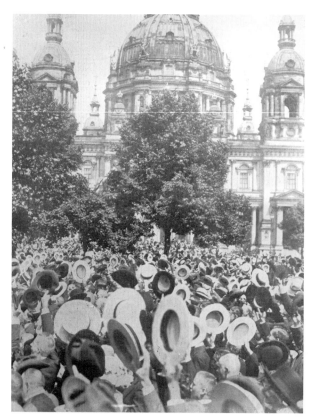

Crowds gather in front of the Berlin
Cathedral, Berliner Dom, cheering the
declaration of war and, lower left,
a similar scene in front of the Royal
Palace.

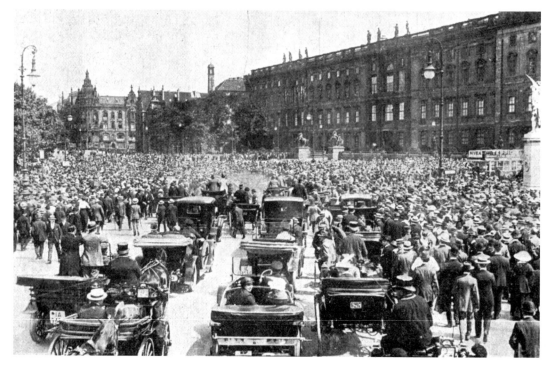

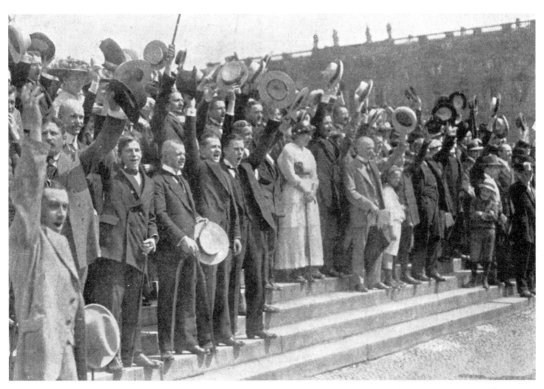

Contrasting scenes in Berlin. *Above:* 'Crowds cheering for war.' *Below:* A different sort of crowd when the declaration of war caused a run on the banks.

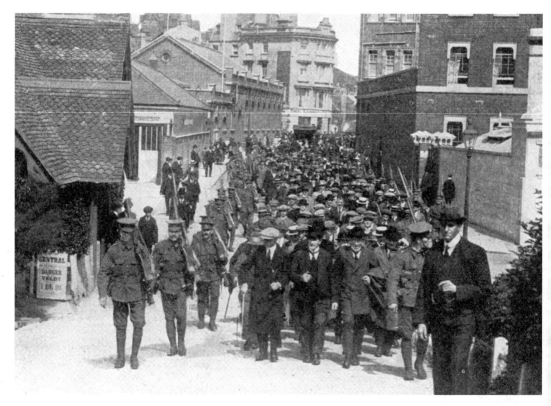

'German reservists, arrested in England when about to embark for the Fatherland, being marched away as prisoners of war. Suspicion of the German community ran high. Below, two *Punch* cartoons from December 1914. 'Owing to the outcry against high-placed aliens a wealthy German tries to look as little high-placed as possible.' And on the right, the fear of German spies. 'Run away, you leedle poys; don't come here shpying about!'

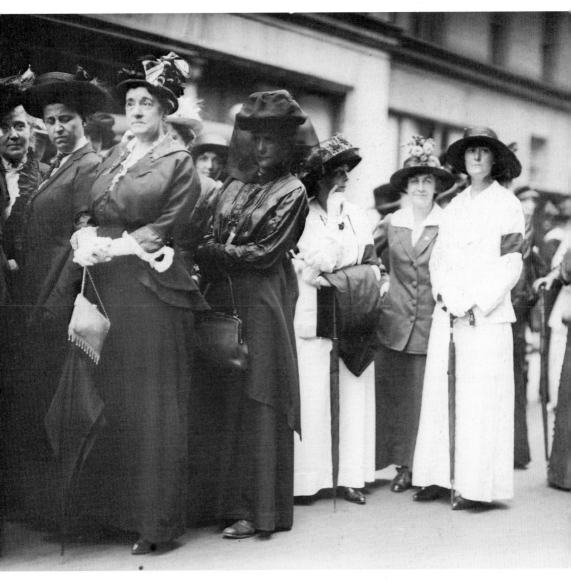

On the other side of the Atlantic, participants in a women's Peace Parade down Fifth Avenue, New York, on 29 August 1914. At the outbreak of the war the USA government had an isolationist policy and was determined to remain neutral. In the event the USA did not enter the war until 1917.

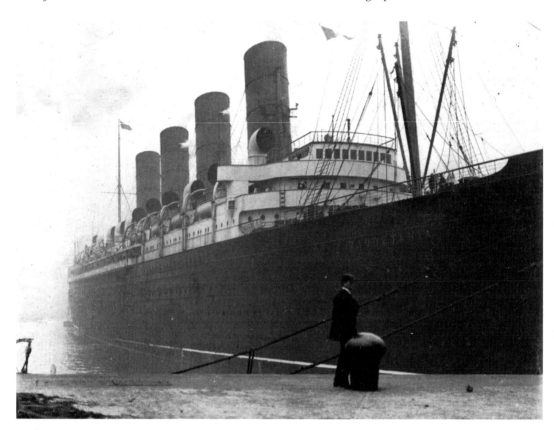

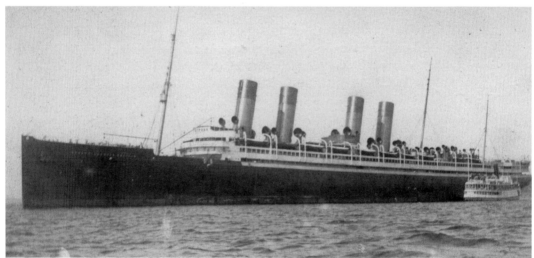

Many merchant ships were caught out at the start of the war, simply being in the wrong place at the wrong time. The Cunard liner *Mauretania*, above, made for Halifax, Nova Scotia, where she lay until a dash across the Atlantic to Liverpool. The German *Kronprinzessin Cecile* failed to escape America, making for Bar Harbour, Maine, where she was interned and taken back to New York. She had made an attempt to camouflage herself as RMS *Olympic*, with black tops to her buff funnels, but the disguise fooled no one.

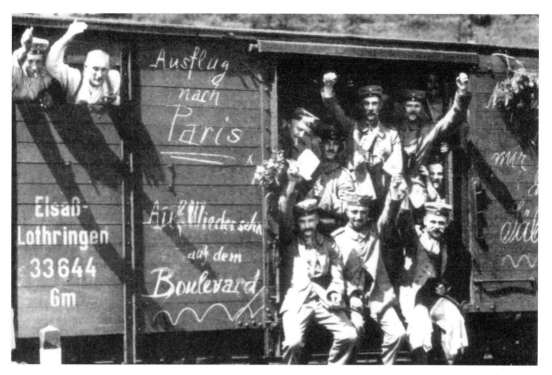

Battle of the Frontiers

German troops head for the front in a railway wagon bedecked with bullish slogans. 'Ausflug nach Paris' – going to Paris – indicates their intended destination. *Below:* The German 47th Infantry Regiments advances across a field in northern France in August 1914. Within a few short months these meadows would be trampled into mud. At Mons the Germans are briefly held before forcing the British Expeditionary Force back three miles.

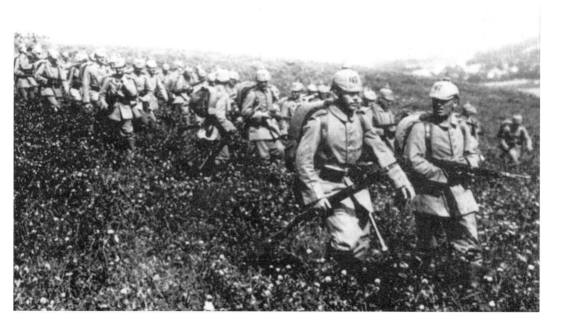

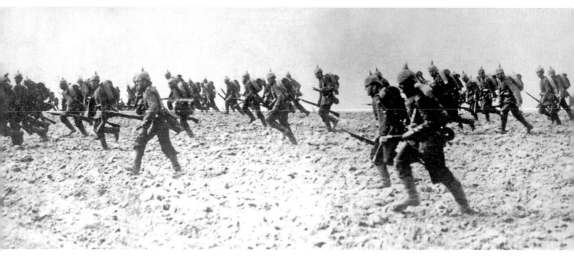

The bold drive of the Germans' Schlieffen Plan pushes on through Belgium and France, sweeping southwards towards Paris. It is finally halted by a French and British counterattack at the Battle of Marne in early September. *Below:* In the early days of the war the Kaiser sustained the role of 'Supreme War Lord' and actively intervened in the planning and conduct of the campaigns. This photograph of the Kaiser addressing his generals was published by the British with the caption, 'All Highest but not All Wisest'.

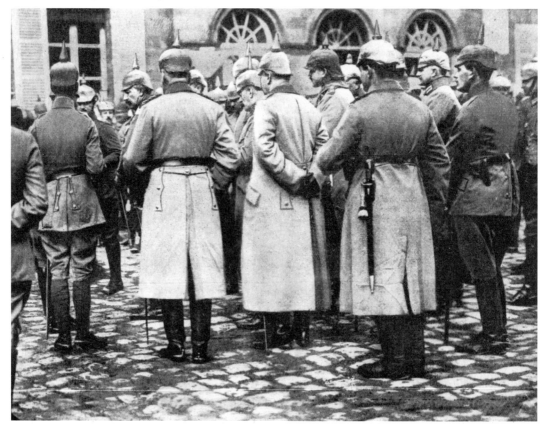

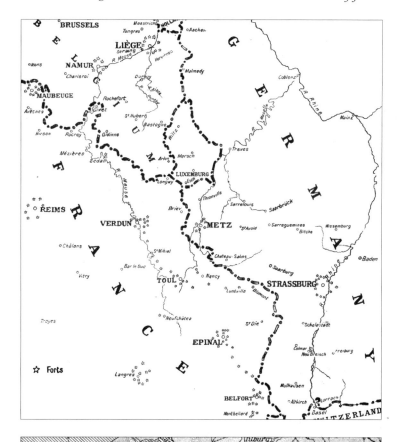

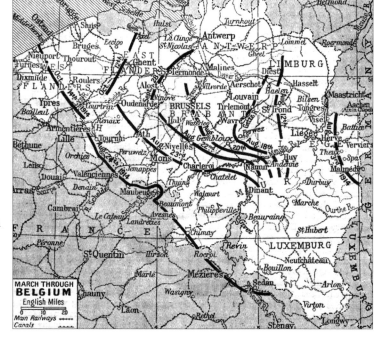

Top right: A map showing the Franco-German frontier before the outbreak of hostilities. The second map shows the various stages of the German advance through Belgium between 3 August and October 1914. By the end of the year the frontline had become virtually static and remained so for almost four years.

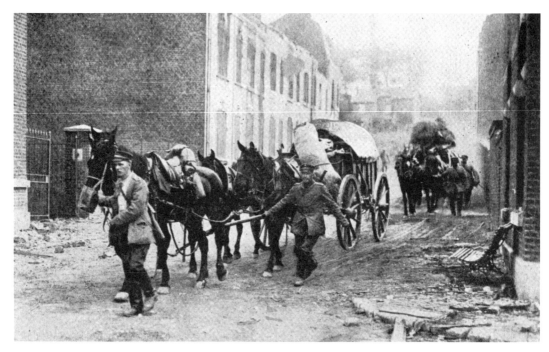

Although the First World War is often portrayed as the first mechanised war, especially through the use of machine guns, the reality, especially in the early stages, was that both sides relied heavily on horses as the main form of transport. *Above:* German forage wagons passing through Mouland, a village on the Belgian frontier with Holland and to the north of Vise. It was one of the first villages to be badly damaged by the invading army. The cavalry went by road, but for the infantry the main means of transport was often by train, if available, and then on foot for the most part. The photograph below shows an attack on a village just inside Belgian territory.

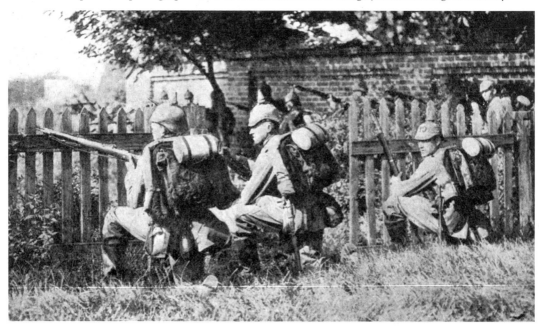

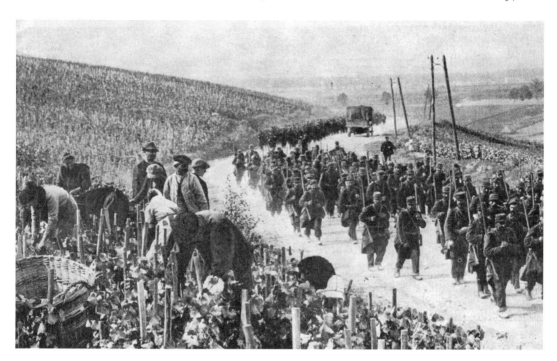

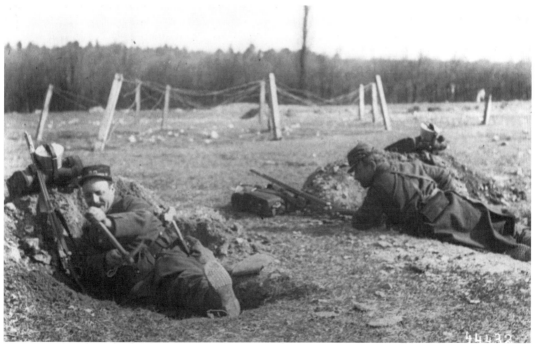

Above: Campaigning in Champagne. War came to this region of France when the grape harvest was about to be gathered. Old men, women and children stop their work to watch. Few of these soldiers marching along a dusty road could have imaged the conditions they would come to endure. However, the shallow trenches, little more than hollows big enough to accommodate one or two men at a time, were harbingers of the type of war yet to come.

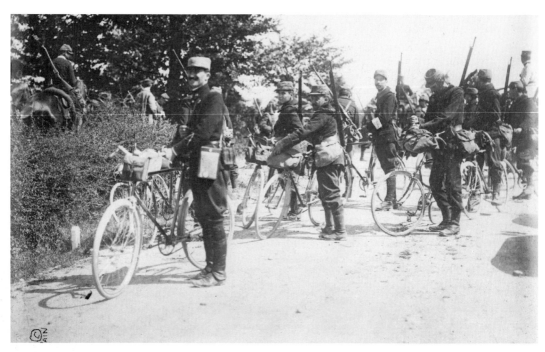

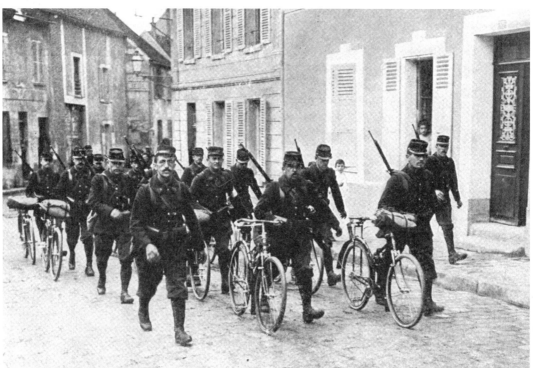

'Cyclists of the French Army.' Two images that seem alien to our preconceptions of the First World War. French Cyclist Companies on the move, although mostly pushing their bikes, it would seem, rather than riding them.

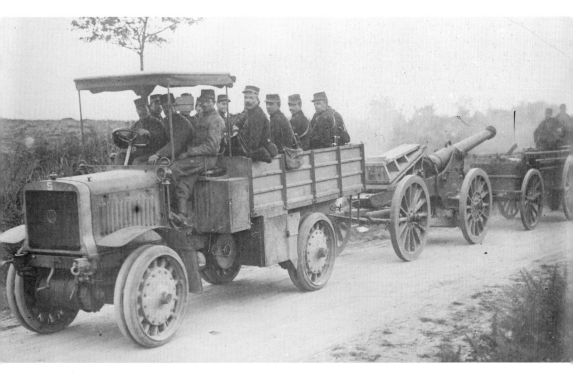

Motorised transport began to make its presence felt and continued to be used throughout the war wherever the road conditions permitted. Above, motor vehicles are seen acting as tractors for French siege guns, and, below, a row of steam-powered lorries are being pressed into army service.

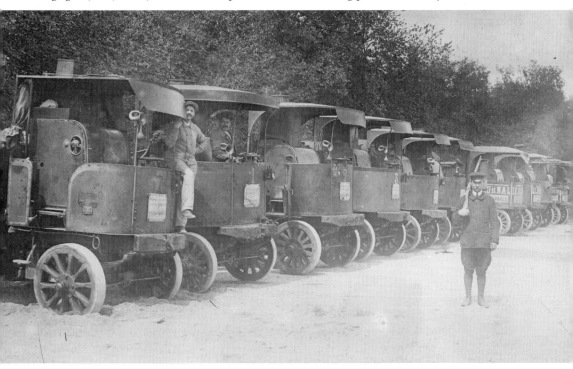

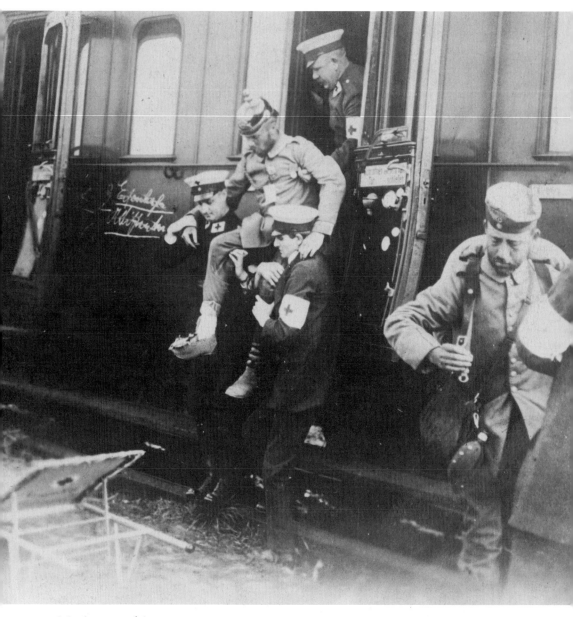

Moving casualties

In the early stages of the conflict almost any form of transport would be commandeered to transport casualties to the. *Above:* Clearly this hospital train has been created using conventional carriages.

Opposite: A wounded German is brought into Ostend on 25 August. Inevitably, such scenes were exploited as propaganda. The original caption states, 'A wounded barbarian in the hands of a chivalrous foe. A number of wounded Uhlans were brought into the town. They were treated with humane solicitude by captors far too chivalrous to rival the ruthless example of the Kaiser's vengeful cavalrymen.' The lower image shows a far more basic mode of transporting the wounded with train wagons at Nancy.

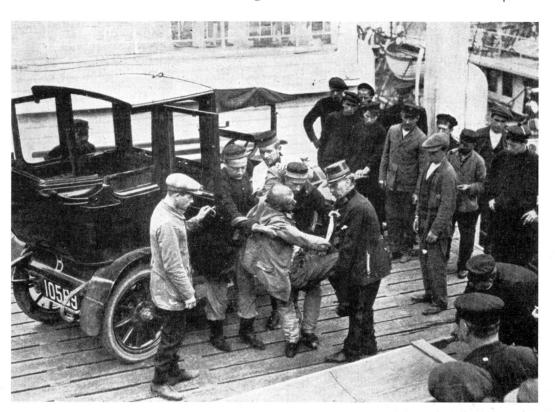

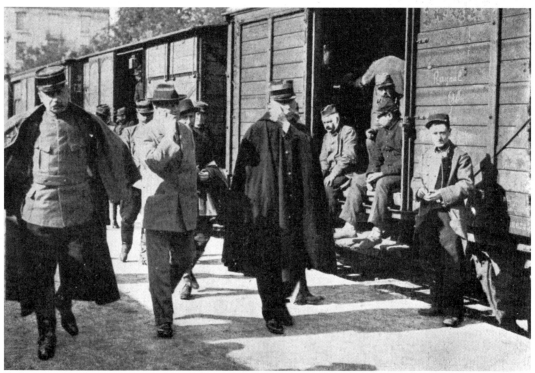

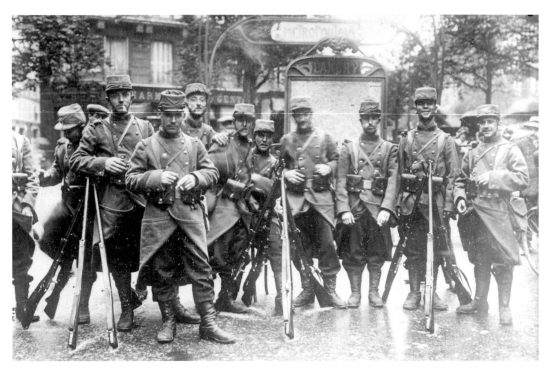

On the streets of Paris

With Paris under threat, the French authorities positioned troops to guard key locations, such as the entrance to the subway as shown above. *Below:* A group of French soldiers parade in front of this Parisian crowd.

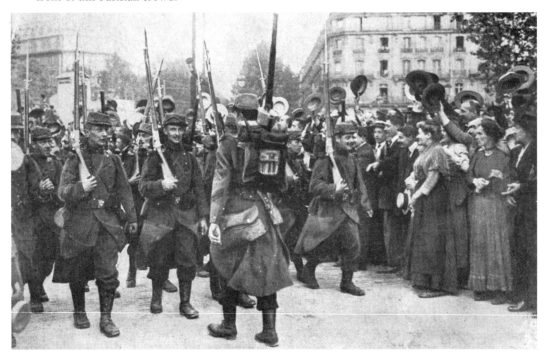

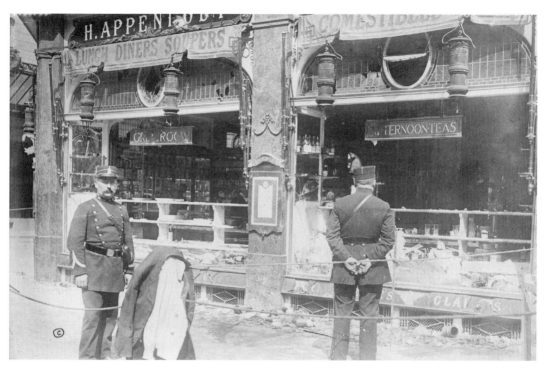

Above: A Parisian mob has smashed the windows and wrecked this German-owned restaurant.
Below: Reservists from the outlying country entering Paris. Anticipating a German assault on
the city, the municipal authorities had stockpiled some food supplies, including 100,000 kilos
of powdered milk and around one million kilos of milk in condensed form.

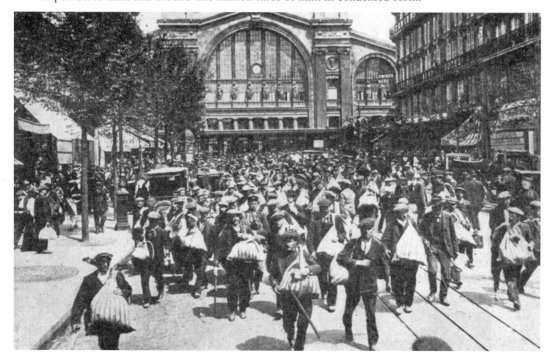

A WASTE OF GOOD MATERIAL.

BRITANNIA (to Lord KITCHENER). "WELCOME BACK! I WISH A BETTER POST COULD HAVE BEEN FOUND FOR YOU—BUT OUR POLITICIANS ARE A LITTLE AFRAID OF STRONG MEN."

[Lord Kitchener's new post is the Mediterranean military command. Its last occupant resigned on the ground that it didn't give him enough employment.]

REINFORCED CONCRETE.

JOHN BULL. "IF YOU NEED ASSURANCE, SIR, YOU MAY LIKE TO KNOW THAT YOU HAVE THE LOYAL SUPPORT OF ALL DECENT PEOPLE IN THIS COUNTRY."

Above: Two cartoons, from 1910 and 1914, featuring the rise of Lord Kitchener.

Lord Kitchener

Field Marshall Horatio Herbert Kitchener, the 1st Earl Kitchener, was a professional soldier who first won fame by winning the Battle of Omdurman in 1898 to secure the Sudan, after which he was given the title Lord Kitchener of Khartoum. As Chief of Staff in the second Boer War (1900–1902) he played a vital part in Lord Roberts' campaign and he succeeded Roberts as Commander-in-Chief. In 1914 the Prime Minister, Herbert Asquith, appointed Kitchener as the Secretary of War. Recognising that this would be a long drawn-out conflict, Kitchener organised the largest volunteer army that Britain had ever seen. The iconic image of Kitchener with pointed finger was originally produced by artist Alfred Leete as a cover illustration for the *London Opinion* magazine. In addition to creating the so-called 'Kitchener's Army', the Secretary of War oversaw a massive expansion of munitions production at the start of the war. However, after being blamed by the newspapers for a shortage of shells, in the spring of 1915 he was stripped of his control over munitions and strategy and his public reputation was severely dented. On 5 June 1916 Lord Kitchener sailed to Scapa Flow, where he boarded the warship HMS *Hampshire* for a diplomatic mission to Russia. Later that evening the *Hampshire* was caught in appalling weather en route to Russia and while off the Orkney Islands it struck a mine laid by the German submarine U-75. Kitchener, his staff, and 643 out of 655 crew were drowned.

Recruiting

At the outbreak of the First World War, Britain's confidence in its naval superiority and the protection offered by its waters had left the nation unprepared for a drawn-out land war. The Army consisted of around 710,000 men including reserves, of which only 80,000 were regular troops, trained and ready to fight. This was far less than either the German or French armies. The British Army was made up of six divisions and one cavalry division within the UK, and a further four divisions overseas. There were also fourteen Territorial Force divisions, plus 300,000 men in the Reserves. The Secretary of State for War, Lord Kitchener, feared that the untrained Territorials would be ineffectual and despite the popular feeling that it would be 'all over by Christmas', he anticipated a far longer and drawn out war. More men and, as the posters would later state, yet more men were needed. However the British did not use conscription for overseas conflicts, and at first all of the extra men were volunteers, encouraged to enlist through the persuasive propaganda of the time and, in no small measure, by the countless recruiting posters that beckoned and pointed on every street, as well as peer pressure from friends, colleagues and family.

In an age long before television the posters were the most immediate means of mass communication available, especially with their target audience, the mostly

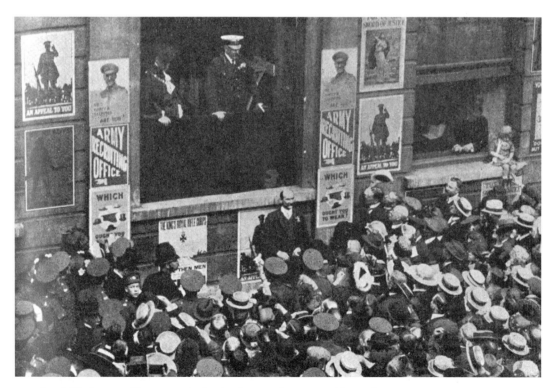

Lord Kitchener addresses an enthusiastic crowd at a recruiting rally.

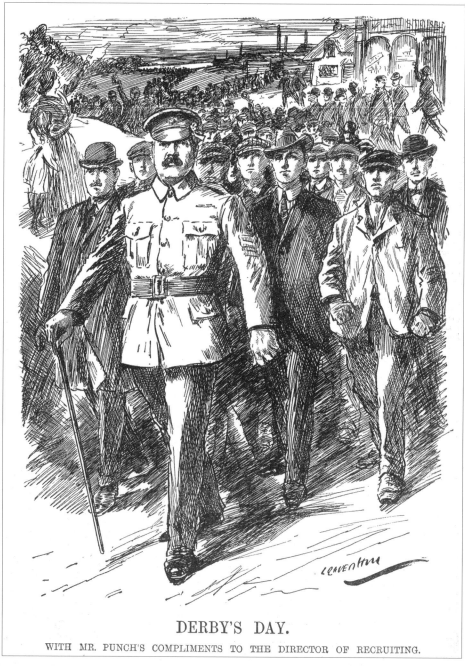

DERBY'S DAY.

WITH MR. PUNCH'S COMPLIMENTS TO THE DIRECTOR OF RECRUITING.

The Derby scheme, named after Lord Derby, encouraged men to 'attest' their intention to enlist. Under the 'group scheme', it encouraged groups of men from a particular area to enlist and fight together in the so-called Pals' battalions.

illiterate or semi-literate men of the working classes who did more than their share to feed the machinery of war. Advertising posters were well established throughout the towns and cities, and while the British style of posters might have lacked the artistic qualities of their French counterparts, or the graphic boldness of the German posters, their slogans and simple imagery were easily and instantly understood by the general public. For the initial period they were fairly innocuous appeals or calls to action, inviting the men to enlist, to 'answer the call'. It was all about duty and pride as the flow of civilians seamlessly became ranks of khaki-clad soldiers. Smiling faces abounded beneath slogans such as, 'Come along boys!' Another featured a smiling Tommy and the wording, 'He's happy and satisfied – are you?'

An initial wave of enthusiasm saw 750,000 men enlist by the end of September 1914, rising to a million by the end of the year. Their reasons for joining up were many and varied and while no doubt some were prompted by unemployment and poverty at home, the recruiting boom did not subside in the wake of the British retreat following the Battle of Mons. Voluntary enlistment continued until the introduction of compulsory conscription in January 1916.

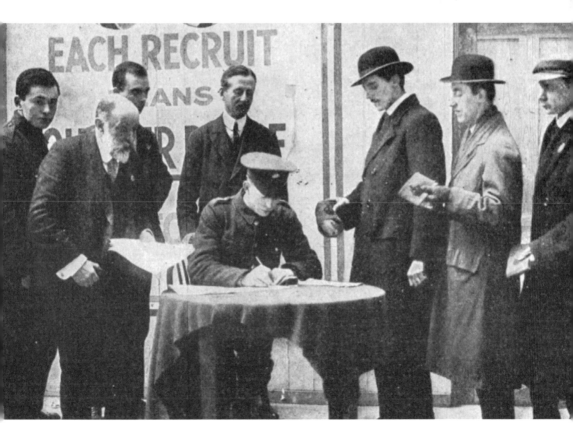

In White City Central Depot a group of 'Derby men' hand in their armlets in exchange for a full uniform.

Playing the game

At the start of the war there had been a push by the professional football clubs to carry on playing in order to keep people's spirits up. However, this backfired when public opinion openly turned against the football clubs. In 1914 Arthur Conan Doyle, the creator of Sherlock Holmes, made a direct appeal to footballers to volunteer for military service. 'If a footballer has strength of limb, let them serve and march in the field of battle.' Many footballers, and other sportsmen, heeded the call and a special Football Battalion was formed as a Pals Battalion within the Middlesex Regiment. During the war the regiment lost more than a thousand men.

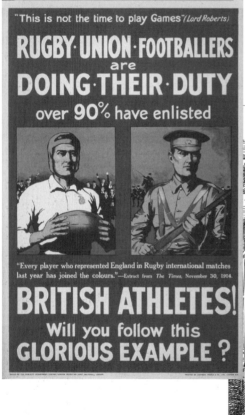

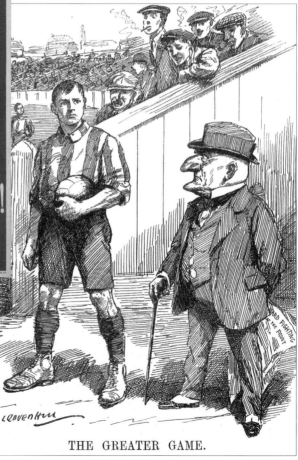

Above: Recruiting poster aimed at the Rugby Union players, and a cartoon from *Punch*: 'Mr Punch (to Professional Association Player). No doubt you can make money in this field, my friend, but there's only one field where you can get honour.'

THE GREATER GAME.

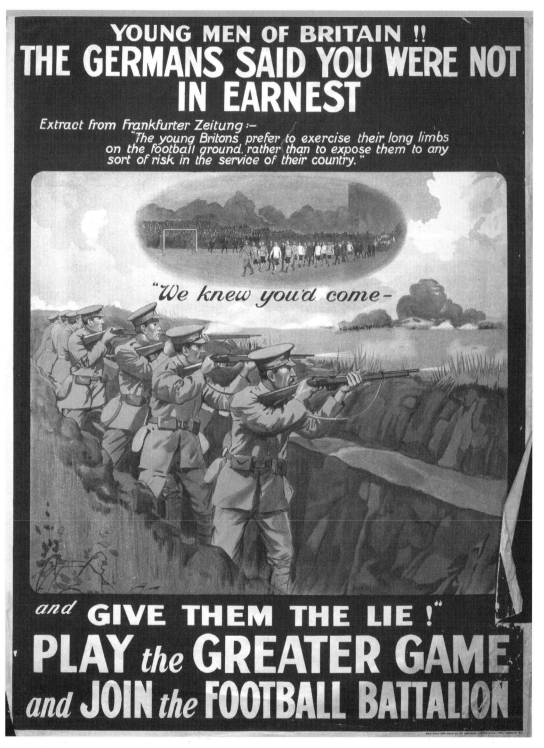

'Play the Greater Game and Join the Football Battalion'. Recruiting poster depicting a very basic form of trench warfare.

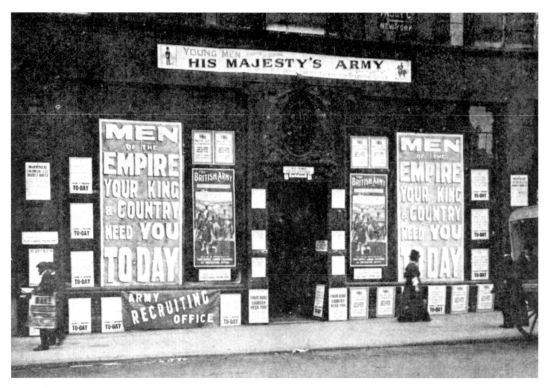

Above: 'The fortunes of war.' The London offices of the Hamburg-Amerika Line transformed into a British recruiting office in 1914. *Below:* Crowds of young men gather outside a recruiting office, eager to do their bit for King and country.

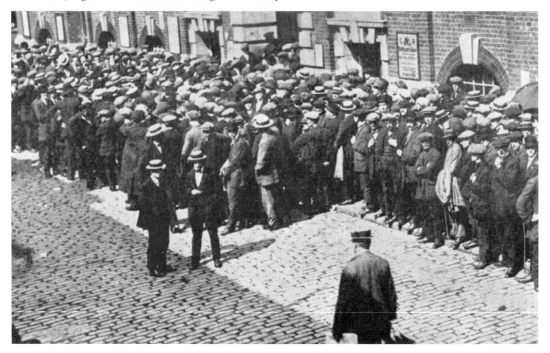

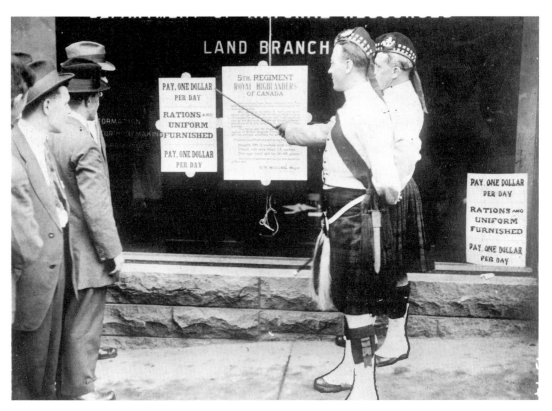

Above: What appears to be a familiar scene outside a recruiting office, but it actually features members of the Royal Highlanders in Canada. Thousands of Brits living overseas, as well as members of the Empire nations were called to bear arms, and they came in their thousands.
Below: This watch factory in Prescot was turned into the barracks for the local Pals battalion.

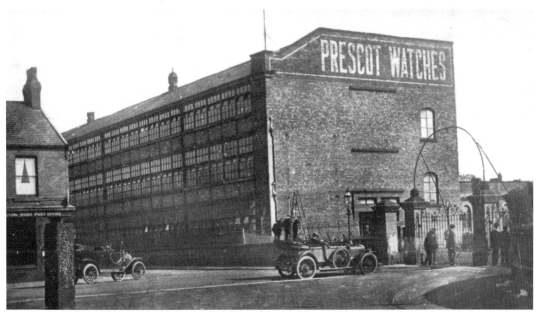

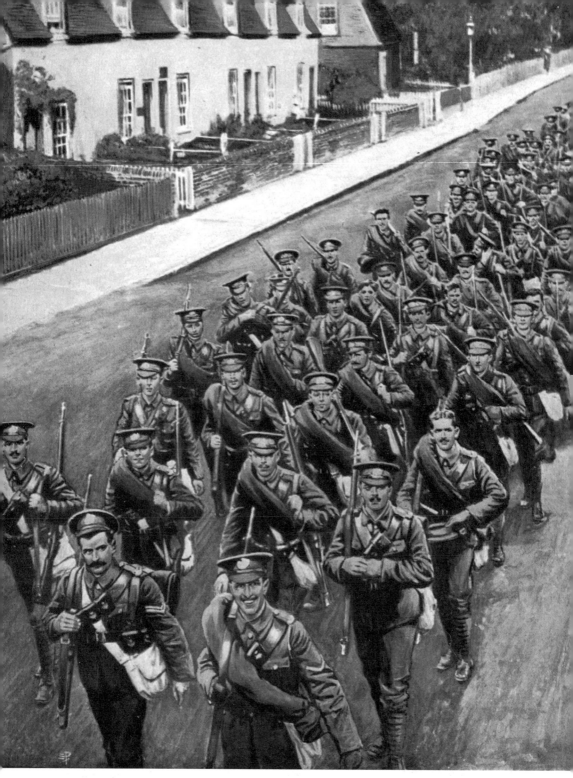

'Kitchener's men on a route march.' With a jaunty stride and smile on their faces, the young men marched off to war oblivious to the overwhelming odds against their survival. They were putting the kibosh on the Kaiser and, after all, it would all be over by Christmas.

Kitchener's Army

Lord Kitchener had been appointed as Minister for War on 5 August 1914, and within days had issued his Call to Arms. Britain's Regular Army was only around 300,000 men and the expansion called for another half a million, who would sign up for three years, or the duration. Within two weeks of the call going out that figure had already been achieved. In shops and in market squares all over the UK, recruiting offices opened.

Below: Lord Roberts is cheered by new recruits of Kitchener's Second Army in Temple Gardens, London. A national hero, Lord Roberts had won the VC in 1858 during the Indian Mutiny. Roberts himself died in November 1914.

Soon, soldiers were being trained in hastily created camps all over the country. Buildings were taken over for barracks, such as the watch factory in Prescot, Lancashire – shown on page 51 – but most training initially took place in basic camps, with tents for accommodation. *Below:* Honorable Artillery Company recruits at Aldershot – note the rag-tag uniforms and footwear. It would take time for the army to manage to provide uniforms for all new recruits and huge effort was required on the home front to manufacture enough khaki cloth for uniforms. These men would be looking after the horses and the guns of the HAC.

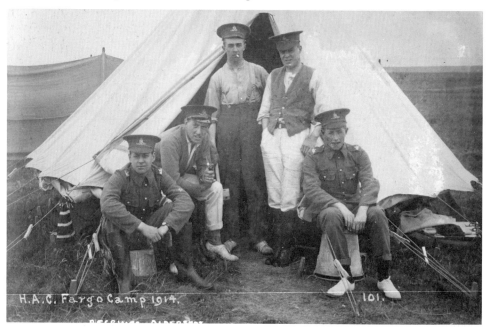

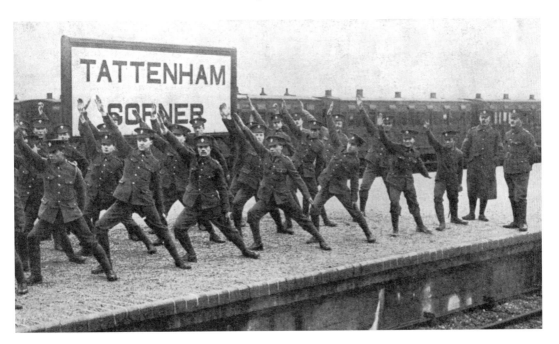

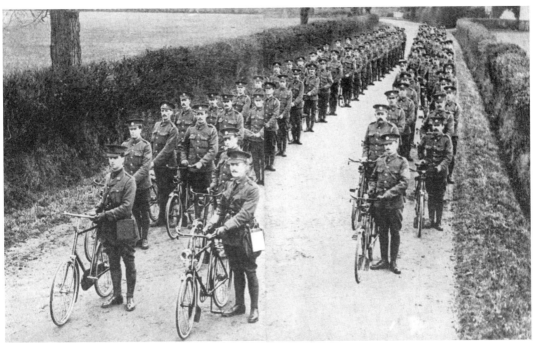

All sorts of unlikely places were used to train this massive army. These men of the 1st Battalion, City of London Territorials, practice Swedish Drill on the platform of Tattenham Corner railway station, next to Epsom Racecourse. Epsom itself was home to tens of thousands of new recruits. The men for Kitchener's Army came from all walks of life but were mainly recruited into Pals Battalions, units of people from the same town or city or from an occupation. These are all motor scouts of the Automobile Association, who have swapped their motorcycles for bicycles.

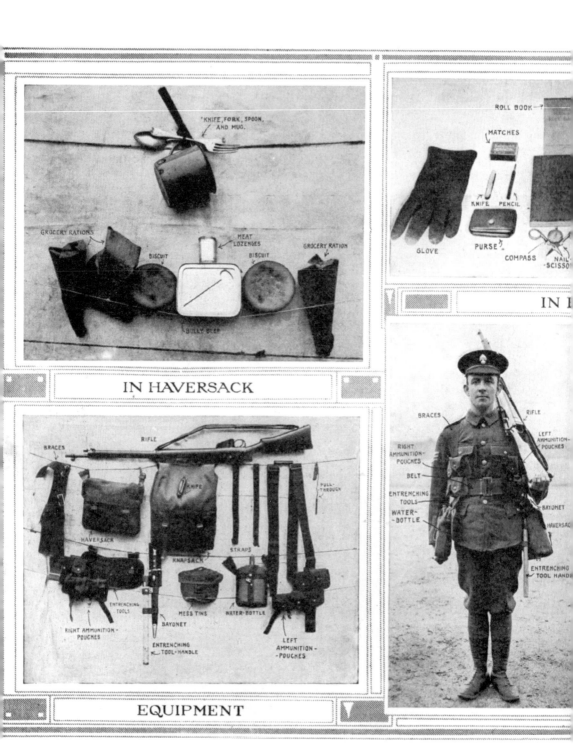

KNIFE, FORK, SPOON, AND MUG.

GROCERY RATIONS

BISCUIT

MEAT LOZENGES

BISCUIT

GROCERY RATION

BULLY BEEF

IN HAVERSACK

ROLL BOOK

MATCHES

KNIFE PENCIL

GLOVE

PURSE

COMPASS NAIL SCISSO

IN 1

BRACES

RIFLE

KNIFE

PULL-THROUGH

HAVERSACK

KNAPSACK

STRAPS

MESS TINS

WATER-BOTTLE

RIGHT AMMUNITION-POUCHES

BAYONET

ENTRENCHING TOOL-HANDLE

LEFT AMMUNITION-POUCHES

ENTRENCHING TOOLS

EQUIPMENT

BRACES

RIFLE

RIGHT AMMUNITION-POUCHES

LEFT AMMUNITION-POUCHES

BELT

ENTRENCHING TOOLS

WATER-BOTTLE

BAYONET

HAVERSACK

ENTRENCHING TOOL HANDLE

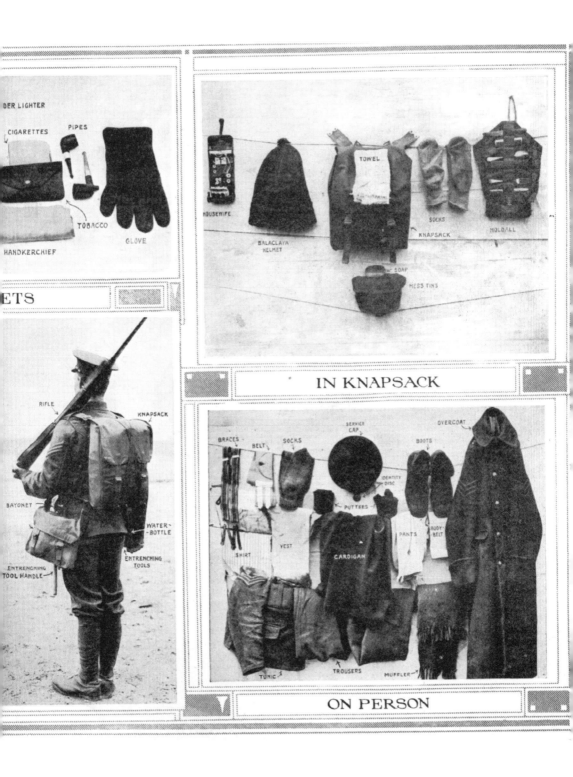

DER LIGHTER

CIGARETTES PIPES

TOBACCO

GLOVE

HANDKERCHIEF

ETS

HOUSEWIFE

TOWEL

BALACLAVA HELMET

SOCKS

KNAPSACK

HOLDALL

SOAP

MESS TINS

IN KNAPSACK

RIFLE

KNAPSACK

BAYONET

WATER-BOTTLE

ENTRENCHING TOOL HANDLE

ENTRENCHING TOOLS

BRACES BELT SOCKS

SERVICE CAP

OVERCOAT

BOOTS

IDENTITY DISC

PUTTEES

SHIRT VEST

CARDIGAN

PANTS

BODY-BELT

TUNIC

TROUSERS

MUFFLER

ON PERSON

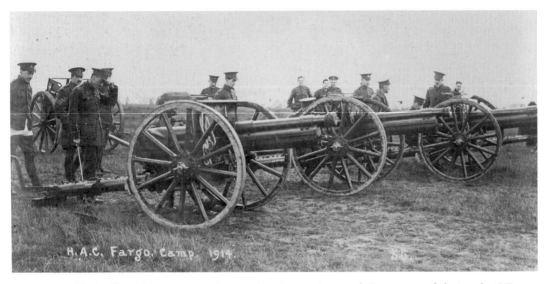

Honorable Artillery Company recruits are given instruction on their weapon of choice, the QF 15-pounder gun. Purchased from Germany in 1900, these guns were a stopgap to replace the obsolete British weapons that had been shown to be inadequate against more modern guns supplied by France and Germany to the Boers. B-Battery of the HAC used these weapons in anger in Aden in 1915.

Manning the trenches

Hastily dug trenches were built all over the UK so soldiers could be given a flavour of life on the Western Front. Of course, unlike in France, the soldiers could go back to a nice warm barracks after a day mock fighting.

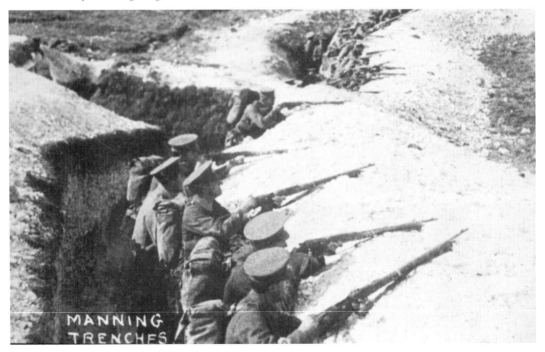

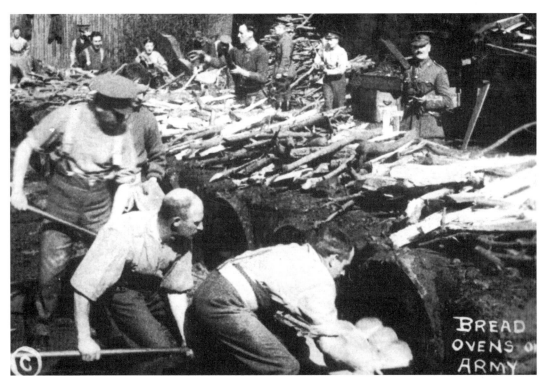

Above: Bread ovens – the army marches on its stomach.

Below: King George V inspecting troops. The King would make numerous visits to the Front during the course of the war.

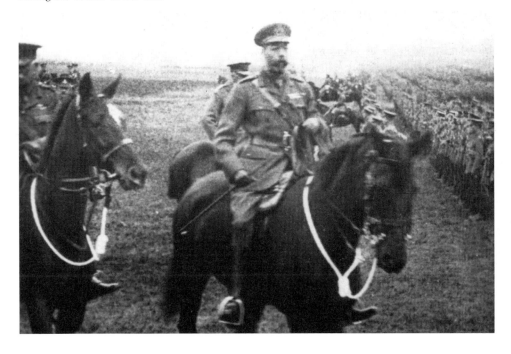

Ready to go to war!

In a year of hard training some three million men had been put into uniform, trained and were now ready to fight. Some were sent to far-flung parts of the Empire so that the regular troops could be released for active service. Little did some of these men know that they would be slaughtered in the trenches within months of finishing their training. The first battalions were ready to enter service in summer 1915 and the next wave were ready in time for the Battle of the Somme, in 1916, which would see tens of thousands of men killed each day in a futile attempt to break through the German lines.

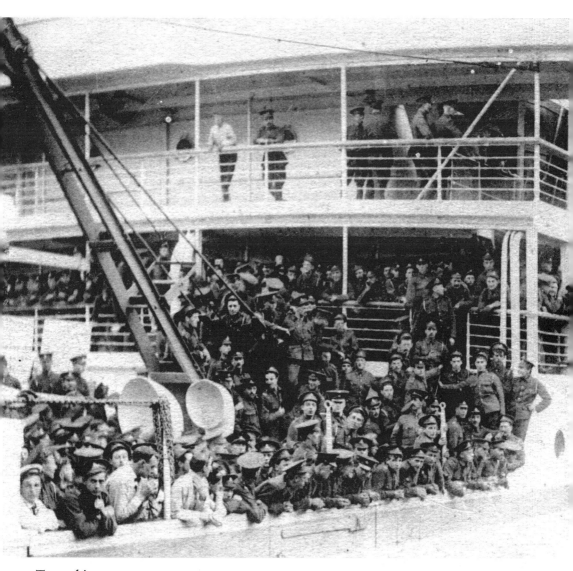

Troopships

Soldiers aboard a troopship. Britain had the world's largest merchant navy and could call up many vessels to use when her troops needed to be mobilised. This view, taken at Southampton, shows troops probably on their way to France.

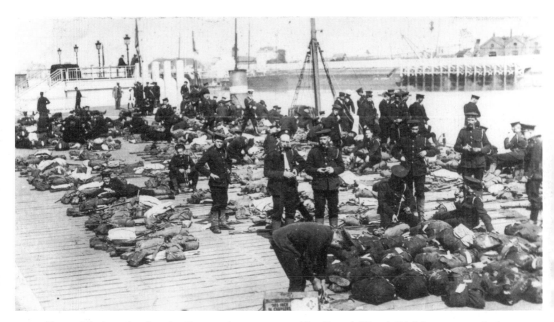

Above: Marines landing in France, August 1914. The Royal Naval Division was rushed to Belgium to try and prevent the fall of Liège and Antwerp. Britain's Royal Naval Division eventually became a major component of the British Army, fighting on all fronts from the Dardanelles to the Western Front.

Below: The Navy quickly began to recruit more men, for ships currently being built and for the Royal Naval Division. They took over the Crystal Palace, in Sydenham, south London, and soon raw recruits were being processed there.

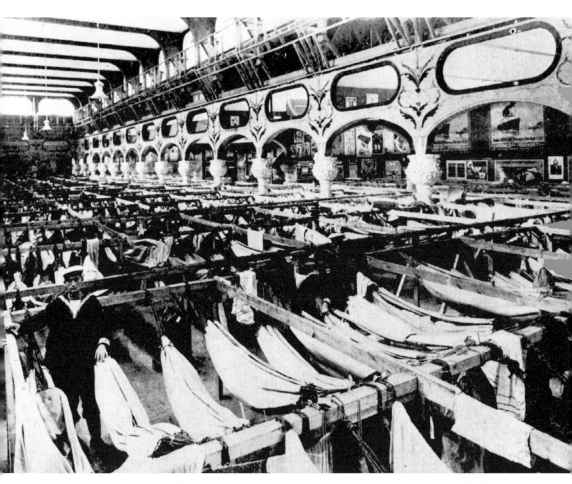

The inside of the Crystal Palace was converted into barracks, complete with hammocks for the soon-to-be sailors, and shipping company posters adorn the walls. *Below:* Recruits await to be assigned their berths.

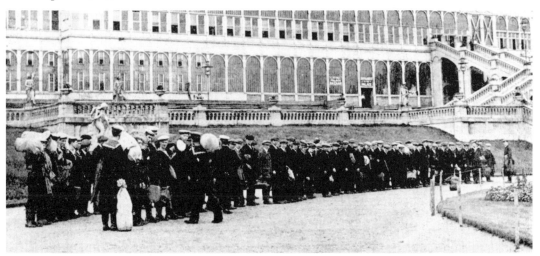

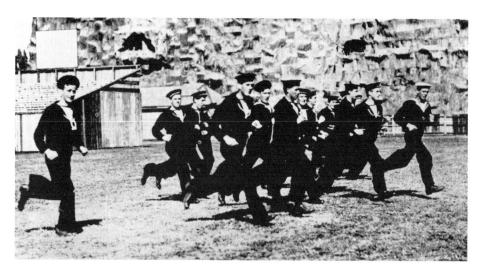

Above: Like their army counterparts, the naval recruits were put through their paces, here in the Crystal Palace's football ground.

Below: This clever ruse was used to make men join the Royal Naval Division. The display had a mirror in which the raw recruit could see the kind of man the Navy wanted. Of course, it was his own reflection in the mirror.

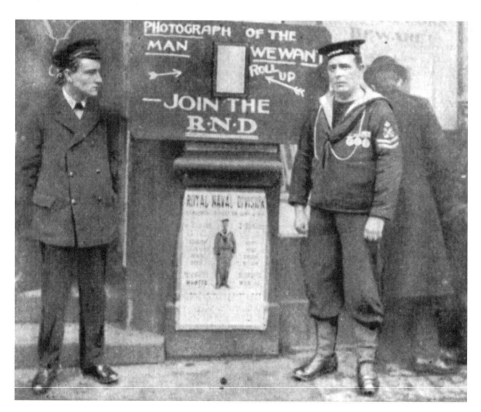

ROYAL NAVAL DIVISION

HANDYMEN TO FIGHT ON LAND & SEA

1ST BRIGADE

BATTALIONS:

"BENBOW"
"COLLINGWOOD"
"HAWKE"
"DRAKE"

RECRUITS WANTED

2ND BRIGADE

BATTALIONS:

"HOWE"
"HOOD"
"ANSON"
"NELSON"

RECRUITS WANTED

VACANCIES FOR RECRUITS BETWEEN THE AGES OF **18** AND **38**

CHEST MEASUREMENT, 34 in. HEIGHT, 5 ft. 3½ in.

PAYMENT FROM 1/3 PER DAY. FAMILY ALLOWANCES.

Besides serving in the above Battalions and for the Transport and Engineer Sections attached,

MEN WANTED

who are suitable for training as Wireless Operators, Signalmen, and other Service with the Fleet.

Apply to the Recruiting Office, 112, STRAND, LONDON, W.C.

The poster seen in the image opposite was this one. It worked a treat as many thousands joined the RND as a direct result of the recruiting campaigns in 1914. Soon, the RND was greatly expanded to include numerous battalions named after famous admirals such as Drake, Hawke, Howe and Nelson.

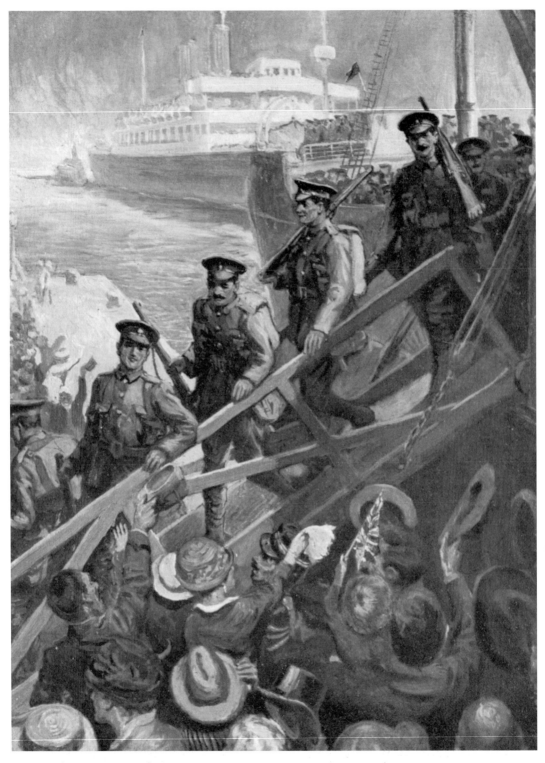

'Kitchener's Men Landing in France.'

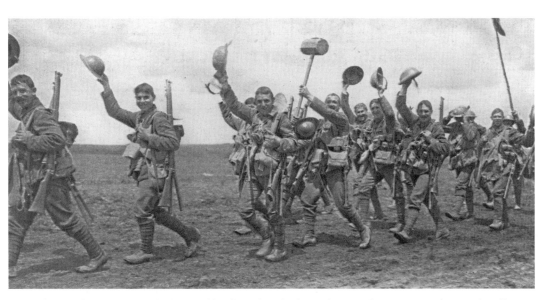

Above: The Worcesters looking jolly pleased with themselves as they go into action. The all-pervading image of the front in the early stages was of the amiable Tommys getting on with the job. Some of the recruiting posters urged the man at home to come and join their pals. 'You'll like it, they'll like it', claimed one. *Below:* French soldiers and members of the British Expeditionary Force toasting their countries.

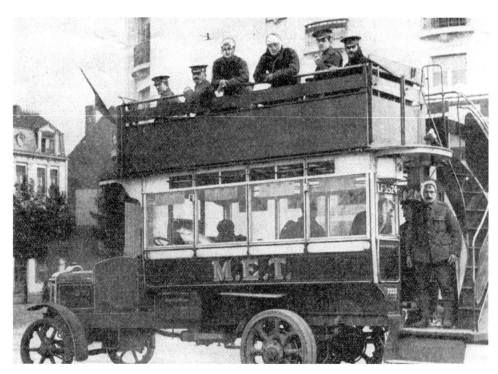

In the early stages of the war some of London's motor omnibuses were hurriedly taken across the Channel to play an invaluable role in transporting the troops and wounded. These buses were pressed into service before their garish red liveries could be covered over. The example shown above carries slightly wounded British troops from Antwerp to Ghent, while, below, these German troops take an obvious delight in their captured London bus.

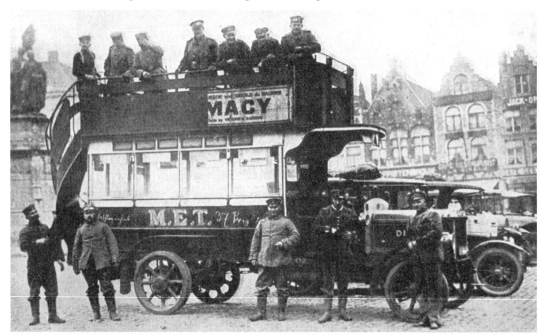

Above: Another vehicle that has changed hands – this time a German truck. These British soldiers are writing their letters home, apparently while smoking cigars.

Below: Not an ambulance, this is a 'motor field kitchen' presented to the British Red Cross Society and St John Ambulance Association.

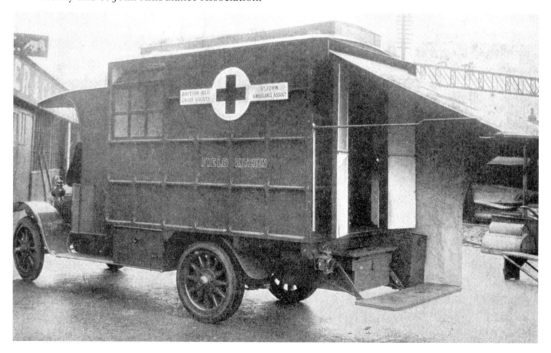

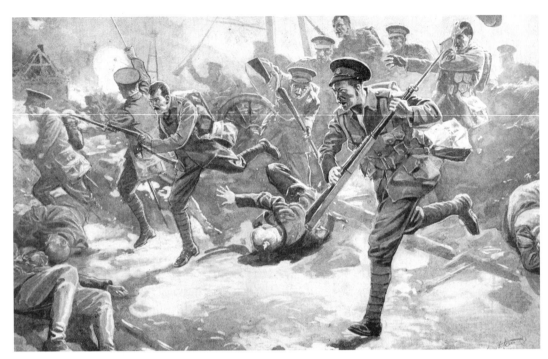

Above: It's all action in this illustration of 'British Infantry's Great Bayonet Charge Through Enveloping German Forces'. It depicts action at Solmes, east of Cambrai, on 26 August 1914. Coming to terms with the fact that ordinary men were killing each other was tackled by the *Punch* cartoon, below, from December 1914, which manages to make light of the business of war. 'Lady in black; "Our Jim's killed seven Germans – and he'd never killed *anyone* before he went to France!"'

Wartime cartoons could mock the enemy, especially the figure of the Kaiser, far more effectively than the official posters might. Published in December 1914, he is complaining about the 'English Force', to paraphrase a scene from *Macbeth*.

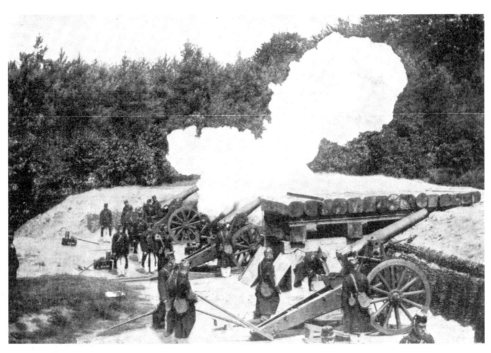

On 16 August the garrison of Liège surrendered. Protected by a series of forts, it had sustained an onslaught of bombardment from the German's big 17-inch siege-guns. Once the Belgian fortress had been neutralised von Bülow's troops pushed westwards towards the River Meuse, causing the Belgian army to destroy bridges as it retreated. *Above:* Belgian guns replying to their German counterparts. *Below:* A German field kitchen captured and used by the Belgians.

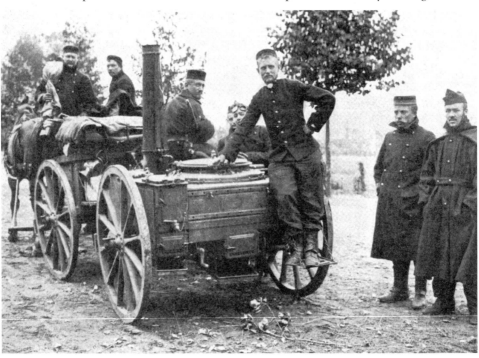

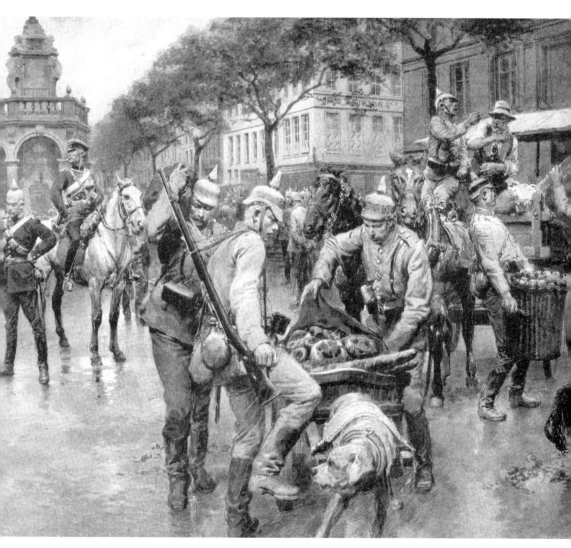

'German troops occupying the city of Liège while the forts still thundered defiance of the invaders' advance.' The attack on Liège had been going on since the opening days of the war and the forts had fallen one by one under assault from the heavy siege guns. On 18 August, Belgium's King Albert had ordered around 75,000 men to retreat to the port of Antwerp. As the Germans advanced there were many reports of atrocities carried out against non-combatants as part of their Shrecklichkeit policy to intimidate the civilian populations.

The big guns

The German siege howitzer known as 'Big Bertha', although this term was later applied to any very large German gun. Its official designation is the L/12 and twelve of these super-heavy howitzers were developed by the Krupp armaments company in the M-Great road-mobile version. The barrel had a bore of 42 cm, 16.5 inches, and firing shells weighing just over 1,800 lbs, the howitzer had an effective range of almost 8 miles.

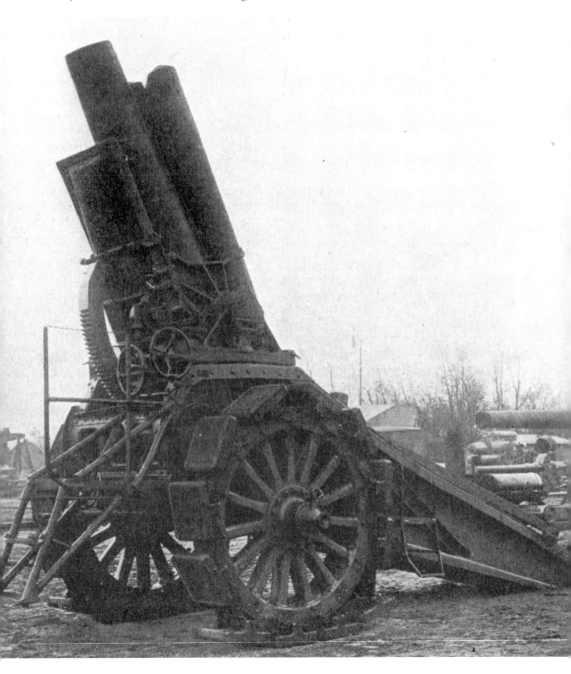

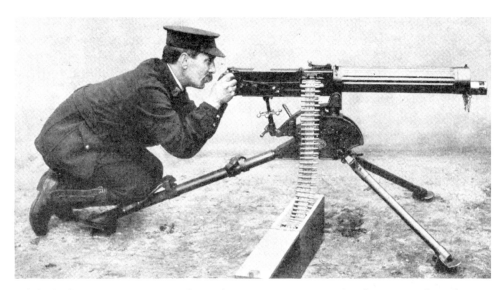

While the howitzers were primarily used as siege guns against fortifications such as those at Liège, it was the development of the rapid-fire machine gun that transformed the battlefield. This is the Vickers machine gun, which was developed by the Vickers Company from the Maxim gun of the late nineteenth century. The water-cooled .303 (7 mm) Vickers Gun, as it became widely known, was produced for the British Army from 1912. Solid and reliable, it took a team of six men, typically, to operate the gun, feeding the ammunition and carrying the weapon, ammo and spare parts. An air-cooled version was developed for aircraft and this became the standard weapon for the British and French air forces throughout the war.

Below: An 11-inch German mortar in transportation mode. The mortar fired an explosive projectile – a mortar bomb – at much lower velocities and shorter ranges than the big siege guns, and with a higher-arcing trajectory. Typically, they are muzzle-loaded. Note the square pads on the wheels to prevent them from sinking into softer ground.

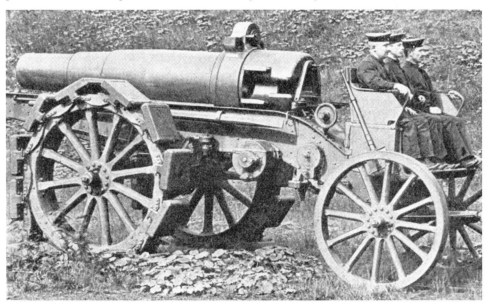

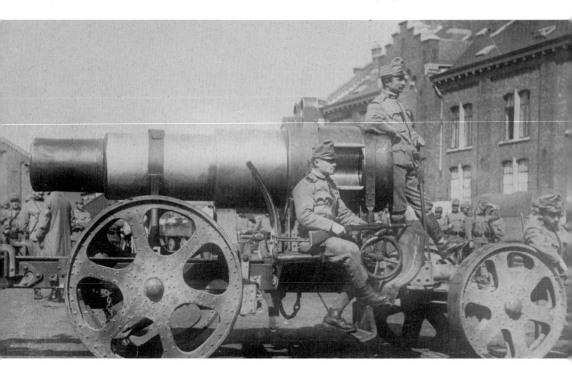

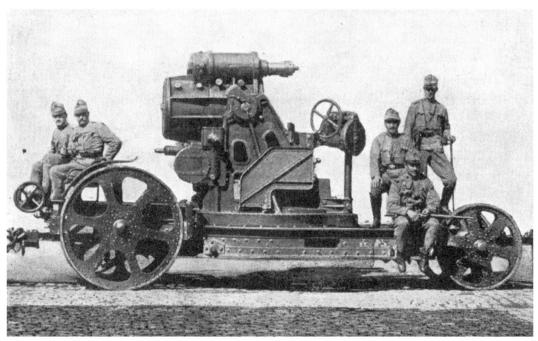

To facilitate transportation this Skoda 305 mm howitzer has been split into two with the barrel carried on a special trolley, above, and the lower mounting of the gun, with the recoil cylinders, on a separate one. Before firing the gun would be mounted up and placed direct on to a firm base, with the wheels removed. The Austro-Hungarian Army loaned eight of these guns to the German Army in August 1914 and they were used in destroying the Belgian fortifications at Liège.

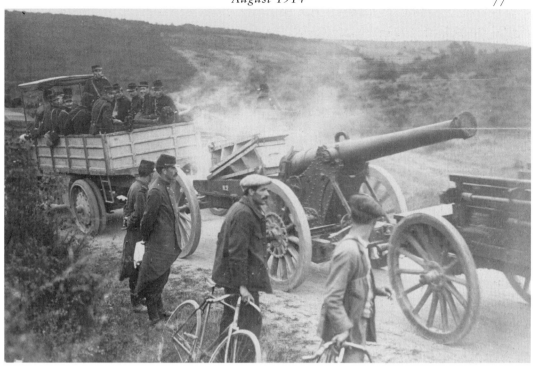

Above: French soldiers in a motor tractor hauling a 'siege gun'. *Below:* These German troops celebrate the capture of a Belgian gun.

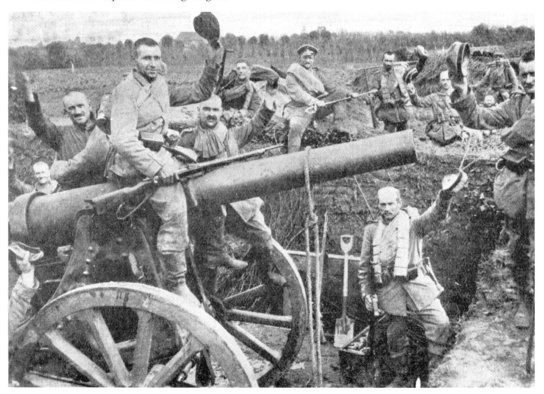

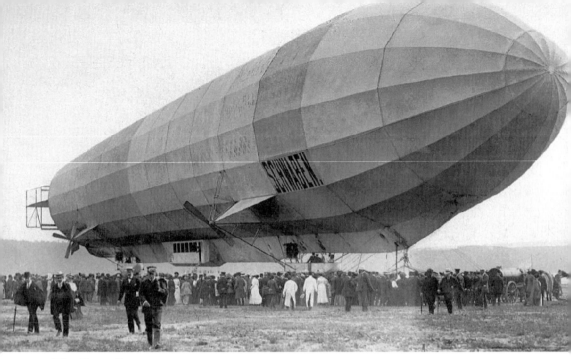

The Zeppelins

At the outbreak of the war the Germany Army had six rigid-framed airships and the Navy had one. Universally known as Zeppelins – after their creator Graf von Zeppelin – they were built by two rival companies, Zeppelin and Shutte-Lanz. Initially their role was seen as reconnaissance, especially for the Navy, while the Army's experiments with the aerial bombardment of Liège and Antwerp proved unpromising. Under the command of Peter Strasser, however, the Imperial Navy's aerial fleet began to grow and they were used to patrol the North Sea. Having demonstrated their range and a degree of reliability, in early 1915 Strasser and the Admiralty persuaded the Kaiser to give permission for attacks on England.

Above: The LZ10 *Schwaben* was one of the pre-war airships operated by DELAG, the Zeppelin passenger service within Germany. *Schwaben* was destroyed in a gale in 1912 and the airships' vulnerability, to the vageries of the weather and later to incendiary bullets, made their tactical value highly questionable.

Left: An unlikely hero, Count Ferdinand von Zeppelin was a retired cavalry officer who developed the rigid-framed airship specifically to give Germany military superiority in the air.

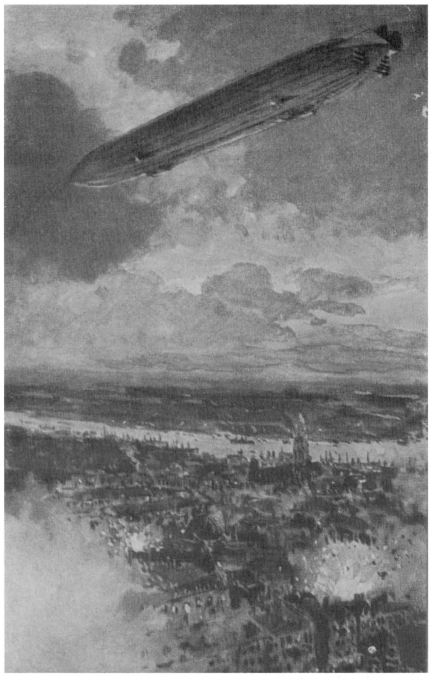

On 6 August the German Army's Zeppelin L6 bombed the Belgian city of Liège, dropping artillery shells instead of bombs, killing nine civilians. Flying at low altitude because of inadequate lift, the airship was peppered with small-arms fire and, leaking heavily, it limped back before being completely wrecked after putting down in a forest near Bonn. The first air raids on Antwerp, shown above, took place on the night of 25/26 August.

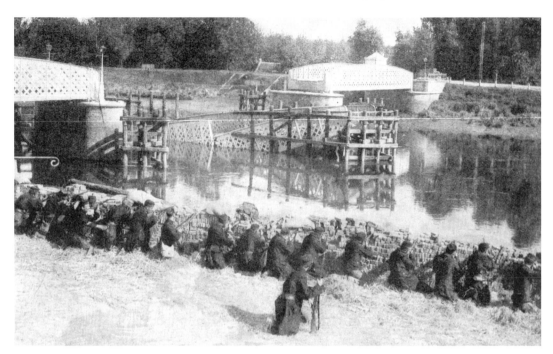

With the surrender of Liège, the Belgians began their retreat to the port of Antwerp on 18 August. The move was completed within two days but by then, 20 August, the Germans had occupied Brussels. The 'Battle of the Frontiers' shifts to the wooded Ardennes region as three German armies continue their sweep through western Belgium towards France. General Joffre, the French commander-in-chief, positions his forces between the Sambre and Meuse rivers to block the main thrust of the German advance. *Above:* Belgian infantry, behind hastily-constructed defence works, wait for the enemy at a crossing point at Hamme, between Antwerp and Ghent. The bridge has been deliberately destroyed to stop the German advance. *Below:* German sentries relax on the banks of the Meuse.

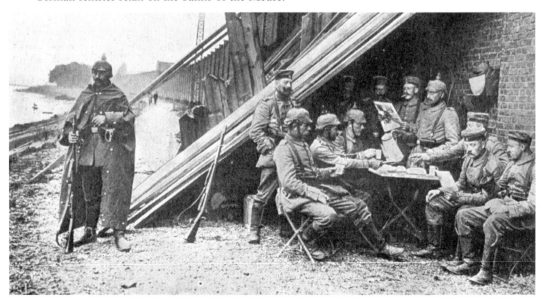

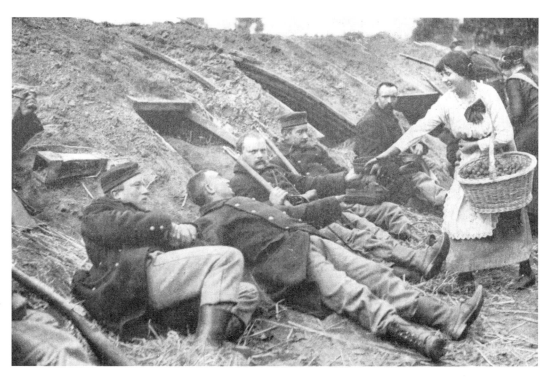

A Belgian woman distributes walnuts to the soldiers in position between Duffell and Lierre during the defence of Antwerp. *Below:* Belgian civil guards at Antwerp.

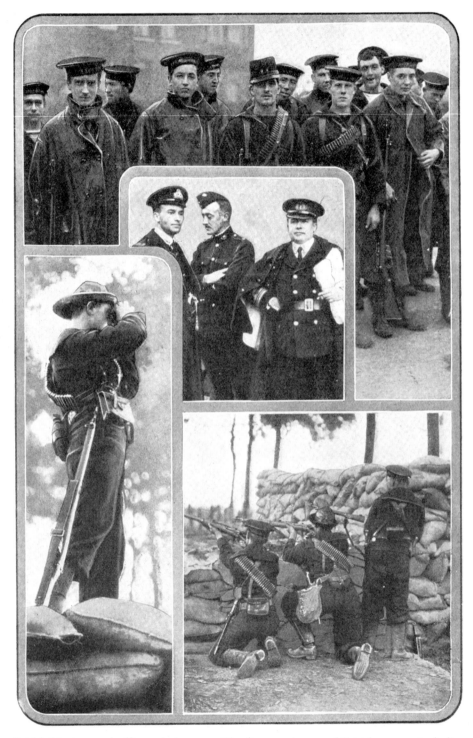

British Marines and officers at Antwerp. The first contingent of British troops, including men of the Royal Naval Division, would eventually arrive in Antwerp in early October, but it was generally recognised that the help had come too late.

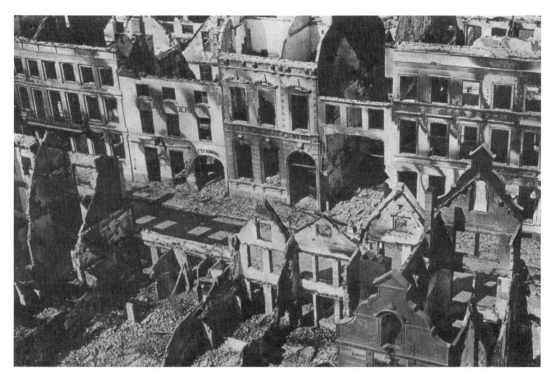

In the march towards Antwerp, several defenceless towns suffered from the German guns. One of the first was Termonde, better known nowadays as Dendermonde. As this photograph shows, above, more than half of the buildings were destroyed by the bombardment and subsequent fires. *Below:* The devastation continued, even after the fall of Antwerp, and this is the scene of devastation in the small coastal town of Nieuport, or Nieuwpoort, which came to mark the north-western point of the Allied line.

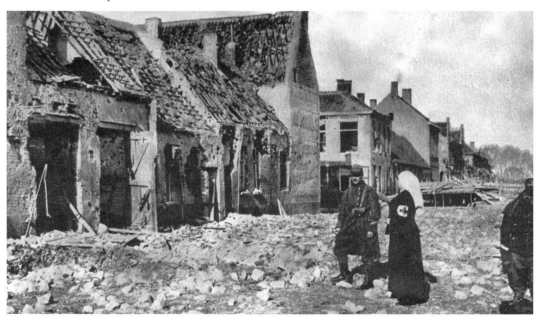

Louis Raemaekers depicts the 'pitiful exodus – the flight from Antwerp'.

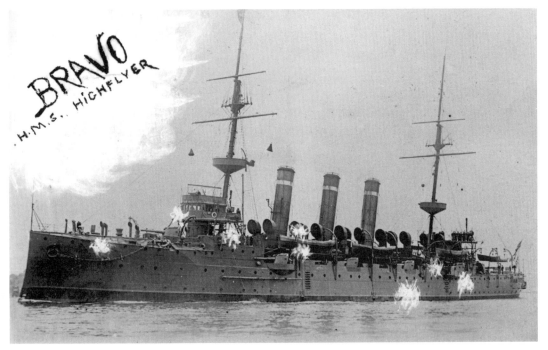

Assigned to search for the German armed merchant cruiser *Kaiser Wilhelm der Grosse* off the coast of Africa, on 26 August, HMS *Highflyer* found her with three colliers at Rio de Oro, in Spanish Morocco. Despite being in neutral waters, *Highflyer* sank the German four-funneled liner. The *Highflyer* lost one crewmember and five were injured. This period postcard shows the damage inflicted on *Highflyer* as a result of the action while the image below shows *Kaiser Wilhelm der Grosse* on her side.

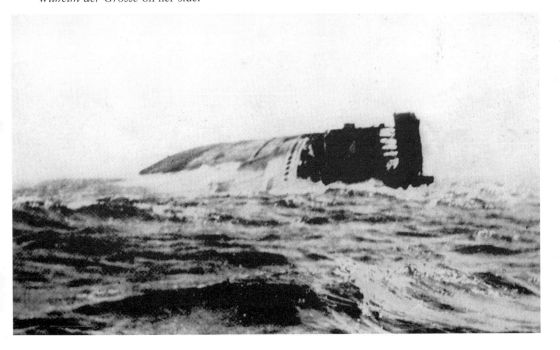

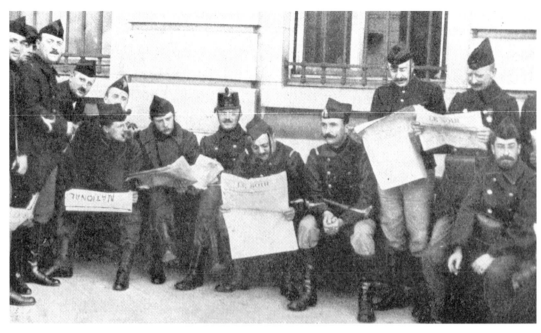

The fall of Brussels

Above: Belgian soldiers read the latest reports on the progress of the war. For them it is a moment of calm before the storm as the capital was occupied by German forces on 20 August. *Below:* The locals look on as German soldiers cross the Place Charles Rogier in the centre of Brussels.

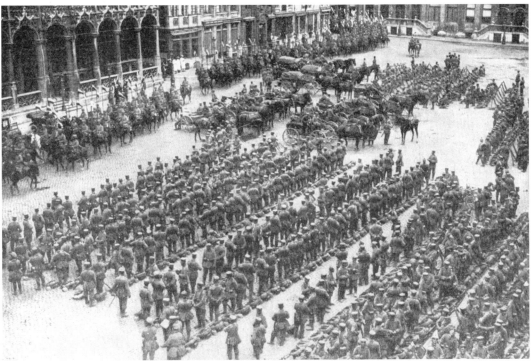

The Lancers, the crack cavalry of the German army, trotting past the royal palace in Brussels and, below, companies of infantry and artillery standing at ease in the Grand Place as the Lancers march through. One observer noted that the distinctive feature of the German occupation of Brussels was 'the detached and almost casual interest displayed by the spectators and inhabitants'. This lack of interest in the welfare of the local population would lead to widespread shortages of food and essential items.

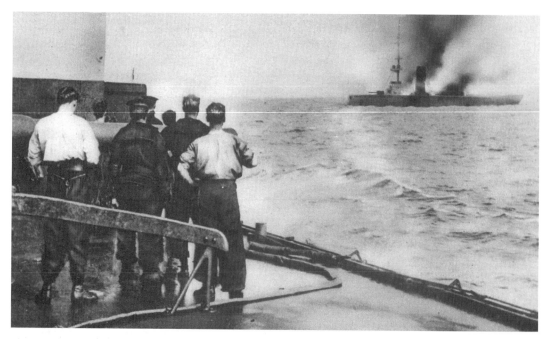

The Battle of the Heligoland Bight was the first proper naval battle of the war. On 28 August 1914, the British planned to attack German patrols off Heligoland, a German archipelago in the south-eastern corner of the North Sea. Thirty-one destroyers and two cruisers took on the Germans with the loss of three German cruisers and one destroyer. SMS *Mainz*, above, was sunk. *Below:* Three British destroyers were badly damaged, including HMS *Laurel*, shown in dry dock after the engagement.

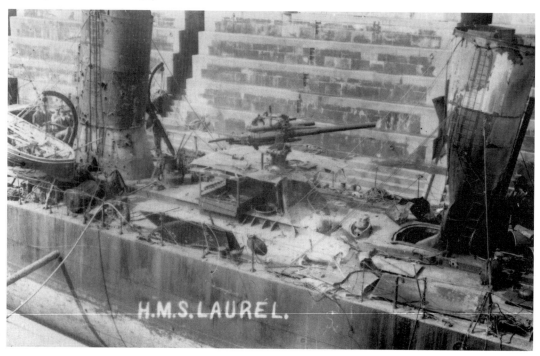

The Battle of Mons

The final encounter of the Battle of the Frontiers was at Mons, where the BEF encountered von Kluck's German First Army. Heavily outnumbered, the British managed to repulse the first German attack on 23 August, but were subsequently forced back, because of the withdrawal of the French Fifth Army to the east. The German chief-of-staff, Helmuth von Moltke, sees the French and British in an apparently disorganised retreat and he modifies the Schlieffen Plan, continuing the advance towards Paris but sending reinforcements elsewhere, including two corps dispatched to the Eastern Front.

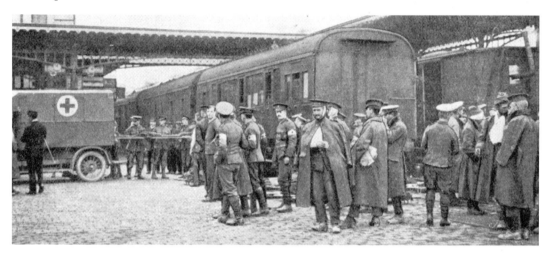

Above: Wounded British troops in the railway station at Boulogne. The caption for the lower image reads, 'Wounded heroes of the Battle of Mons'. It has been calculated that the battle had resulted in 1,600 British casualties, while the Germans losses were around the 5,000 mark.

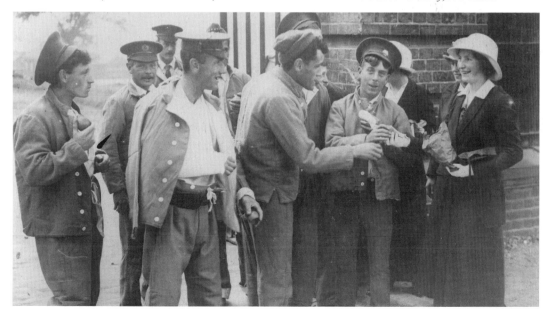

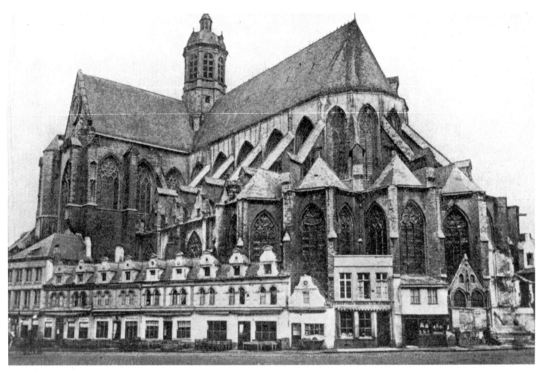

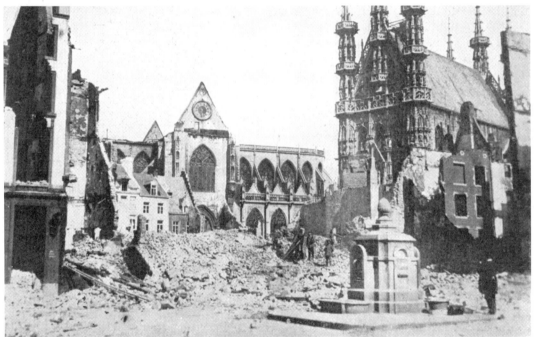

The destruction of Louvain

Louvain, or Leuven, is situated to the east of Brussels and fell to the Germans on 19 August. Over a five-day period from 25 August, the Germans systematically destroyed the old buildings, including the Church of St Pierre, shown here before and after, and the celebrated University Library.

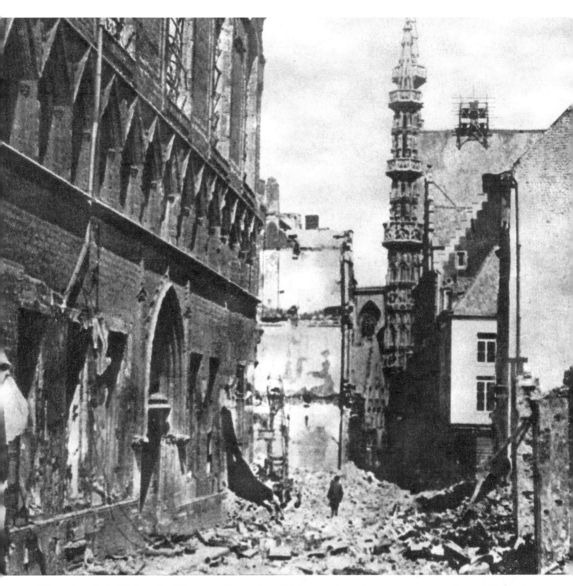

The ruins of the University Library at Louvain, which was viewed as a wanton act of vandalism. In all, about 300 civilians lost their lives and 230,000 volumes, including Renaissance manuscripts, were destroyed. The *Daily Mail* described it as war not only against civilians, but also 'against posterity'.

SEPTEMBER 1914

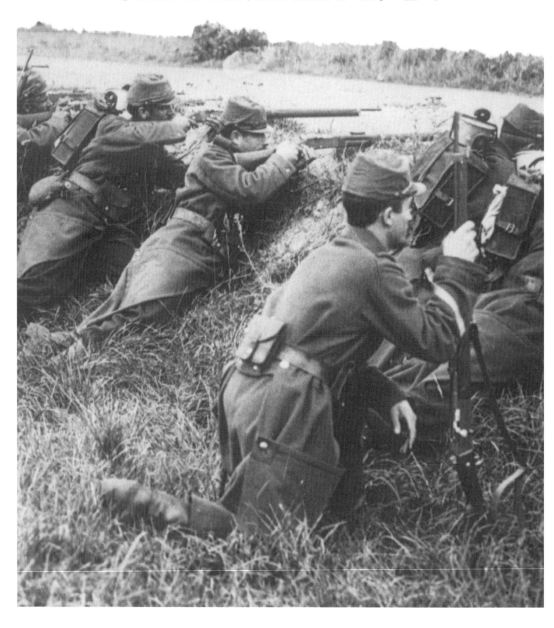

The Battle of the Marne

In the Marne Offensive, also known as the Battle of Ourcq, General Joffre initiated a counterattack against the over-extended German forces holding the line south of the Marne River to the east of Paris. The French and British launched their strike on 5 September to exploit a gap between two German armies. As the final component of the Marne offensive, Joffre orders the French Third Army to attack the German Fifth Army in the Argonne Forest, north of Verdun. There is fierce fighting, and on 9 September the Germans withdrew their forces back from the east of Paris. It is a pivotal point in the war, proving that the Schlieffen Plan, which called for a single sweeping victory over the French, was unworkable. With fighting on two fronts, it marks the start of a far longer and drawn-out conflict.

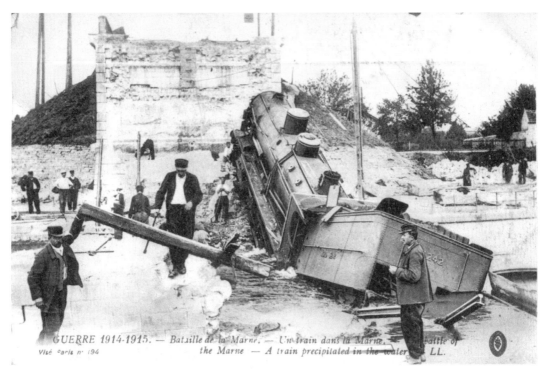

GUERRE 1914-1915. — Bataille de la Marne. — Un train dans la Marne. — Battle of the Marne — A train precipitated in the water LL.
Visé Paris n° 194

Above: Explosive charges designed to bring down the bridge over the river Ourcq also caught this train carrying French wounded.

Opposite page: French troops behind a ditch overlooking the Marne.

Above: German ammunition abandoned at Marne. *Below:* 'Twixt steel and water – how British and French infantry cut off some of the retreating Germans during the Battle of the Marne.' A typically dramatic illustration of the times, but Marne was seen as an important and much-need victory for the Allies.

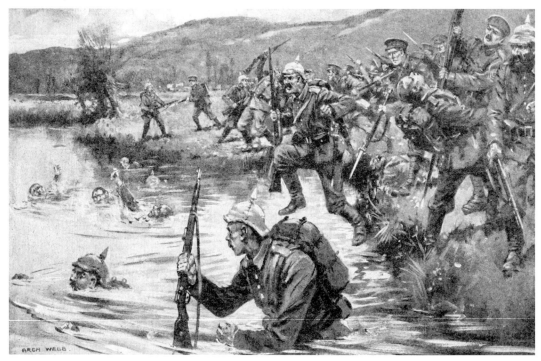

The *Carmania*

The Cunard liner *Carmania* was converted into an armed merchant cruiser at the start of the war. She spent the early months travelling the coast of South America and the Caribbean searching for German and Austro-Hungarian ships. On 14 September, off the coast of Brazil, she encountered the almost brand new *Cap Trafalgar*, a converted German liner. After a fierce battle, the *Carmania*, despite heavy damage from the German liner, managed to sink the *Cap Trafalgar*.

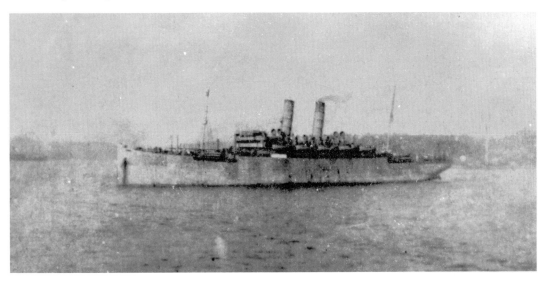

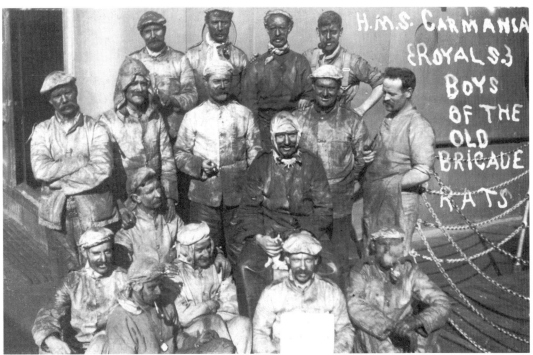

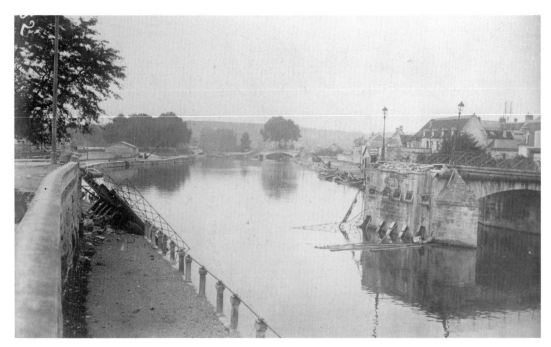

The First Battle of the Aisne was an Allied follow-up offensive against the right wing of the German First Army. It commenced on 13 September in the wake of the German retreat following the battle of the Marne. *Above:* A wrecked bridge at Soissons on the Aisne River.

Below: Belgian infantry passing through the ruined town of Termonde, which is also known as Dendermonde. More than half of the town had been destroyed on 5 September as punishment after the Germans claimed they had been fired on, not by soldiers, but by civilians.

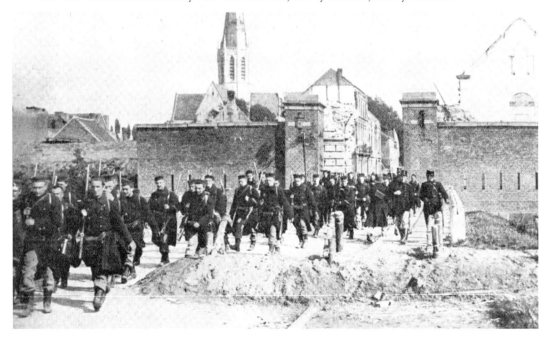

Come into the ranks and fight for your King and Country–Don't stay in the crowd and stare

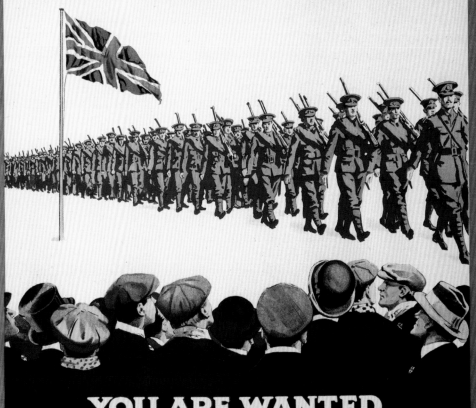

YOU ARE WANTED AT·THE·FRONT
ENLIST TO·DAY

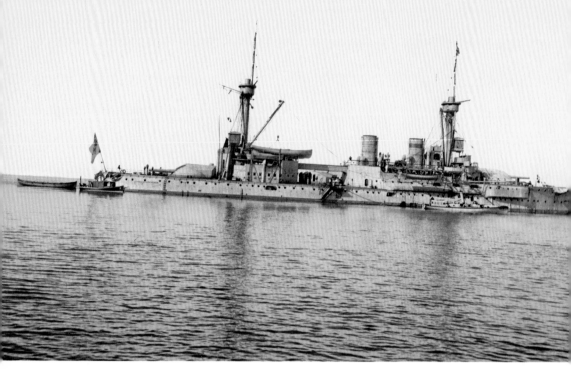

Above: SMS *Kürfurst Friedrich Wilhelm* was the first proper German battleship. Before the unification of Germany none of the German states had a sizeable navy and it was not until the 1890s that expansion became planned and the navy grew in size. Laid down in 1890, she was launched on 30 June 1891 and entered service in 1894. Sold to the Ottoman Empire, the British submarine E11 sank her on 8 August 1915.

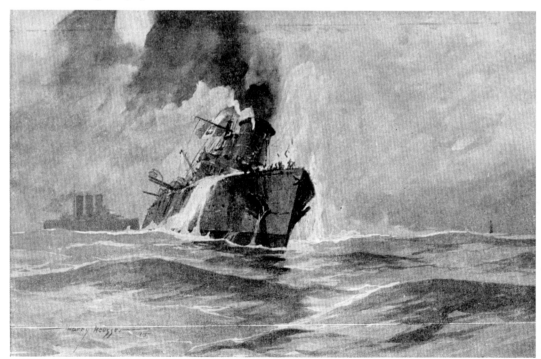

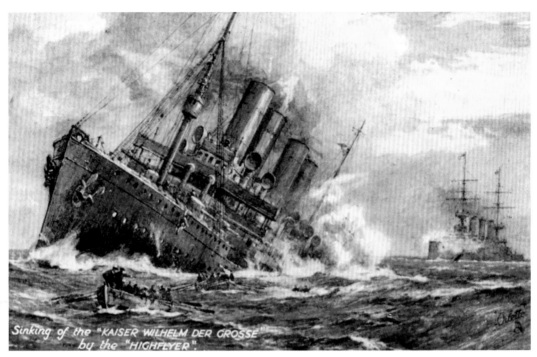

Sinking of the "KAISER WILHELM DER GROSSE" by the "HIGHFLYER".

This page and opposite, below: Three typical propaganda postcards issued by both the United Kingdom and Germany to promote their victories and campaigns. The war saw a huge upsurge in the use of the postcard, both to capture the immediacy of the battles on land and sea and for the troops to send messages home to their loved ones.

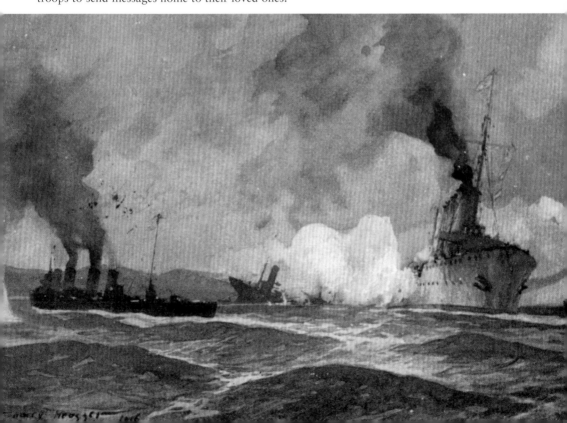

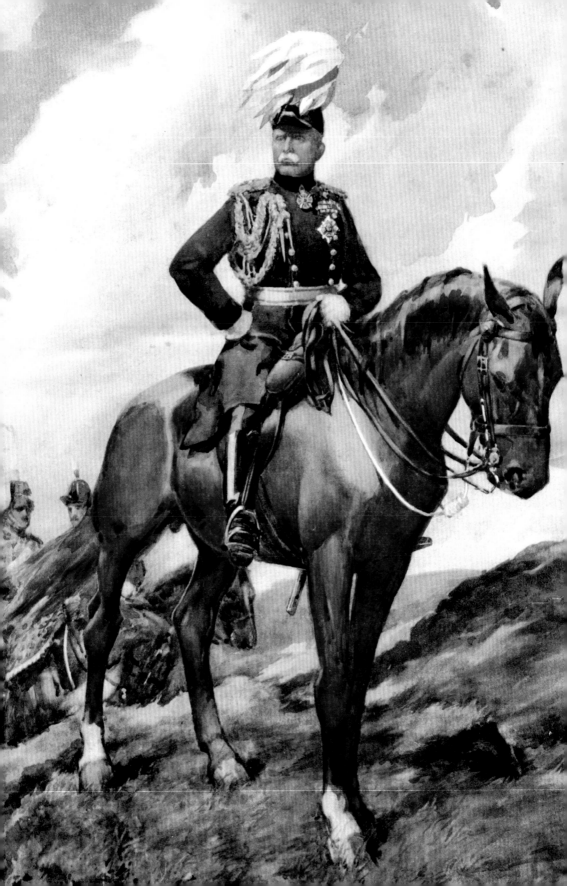

For many French people, making souvenir embroidered silk postcards was one way of providing an income. Many millions of these silk postcards were embroidered during the war, most with hearts and flowers and other sentimental greetings. Some were created depicting the badges of the regiments fighting the war, while others featured naval vessels.

Opposite: Field Marshall John Denton Pinkstone French served as the Commander-in-Chief of the British Expeditionary Force (BEF) for the first two years of the war.

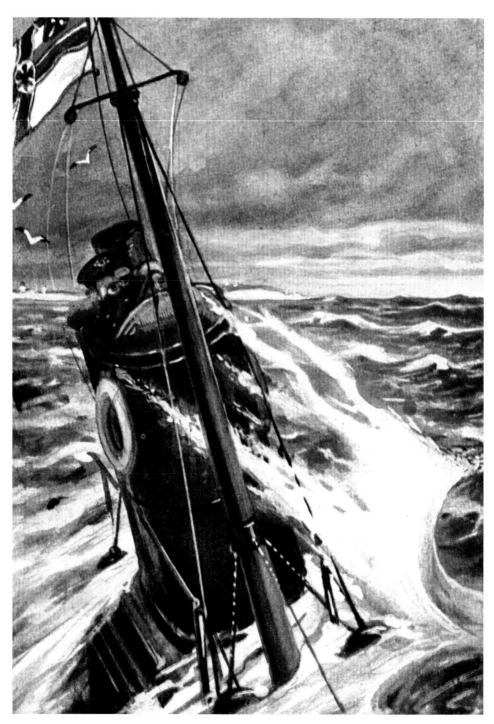

The Germans were quick to capitalise on the potential of the submarine. 1914's subs were primarily designed to work close to the coast and the crews had strict rules of engagement. With the white cliffs of Dover behind, this artist's impression shows a U-boat operating in the English Channel.

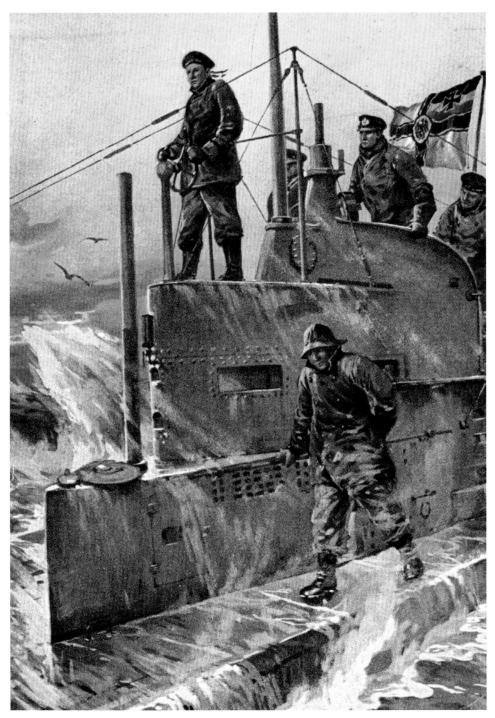

The U-boat campaign intensified throughout the war as the Germans realised it was one of their major weapons against the Allied blockade of the North Sea and the entrances to the Atlantic. A sumariner's job was a dangerous and miserable one, made even more so by the introduction of the depth charge in 1916.

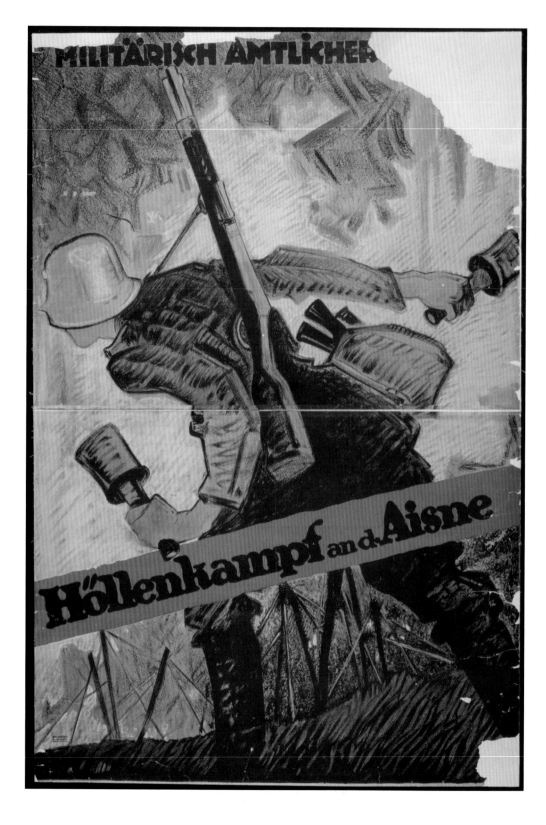

Two very contrasting portrayals of Germany's war. *Opposite:* A home-grown poster romanticising victory at the Battle of Aisne in 1914. *Above:* The poor German soldier bears the full weight of the Kaiser in this cartoon by Dutch artist Louis Raemaekers, who was the son of an ethnically German newspaper editor.

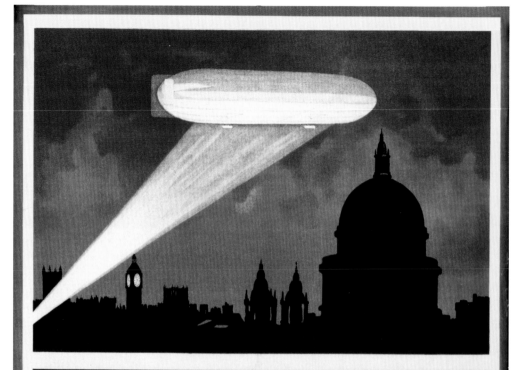

IT IS FAR BETTER
TO FACE THE BULLETS
THAN TO BE KILLED
AT HOME BY A BOMB

JOIN THE ARMY AT ONCE
& HELP TO STOP AN AIR RAID

GOD SAVE THE KING

ISSUED BY THE PUBLICITY DEPARTMENT, CENTRAL RECRUITING DEPOT, WHITEHALL, S.W.

ANDREW REID & CO., LTD., 50, GREY STREET, NEWCASTLE-ON-TYNE.

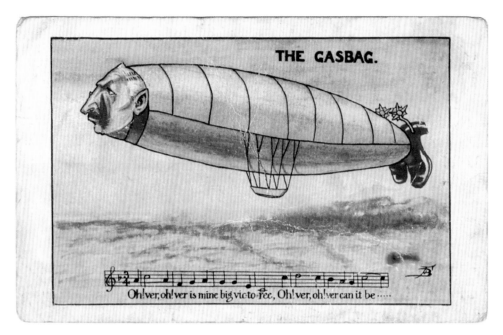

THE GASBAG.

Oh! ver, oh! ver is mine big victo-ree, Oh! ver, oh! ver can it be......

Germany's attempts to use its airships strategically in the field failed miserably, however they were used for reconnaissance, especially of the North Sea, and for the first air raids on Antwerp initially, then Britain with London as a particular target. The Kaiser thought the raids would bring the British to their knees, and while there was fear and many casualties, it only hardened the sense of resolve on the Home Front. Indeed, the Zeppelin raiders provided fuel for countless cartoons, postcards and for the recuiting posters.

LOOKING FOR ZEPPELINS.
THOSE WHO LOOK OUT OF THE WINDOW DON'T SEE MOST OF THE "BOMBS."

Opposite: A raider over London is seen on this recruitment poster, one of several to feature the airships.
This page: Two postcards which defuse the Zeppelin menace though their humour, especially the depiction of Kaiser Wilhelm as 'The Gasbag'.

Niedliche Kleine Dingerchen

This selection of French, British and German postcards, all issued in 1914, give a glimpse of the humour on all fronts. Political, sentimental and often comical, the images range from the spinster and the three million men engaged, to the ever-present louse, as well as cards designed to be sold to the soldiers of the Dominions and the empire. The Navy featured much in the war, and did so on the postcard front too. Postcards were easier to censor, with their limited content and ease of reading by everyone from the Censor himself to the postman delivering the mail.

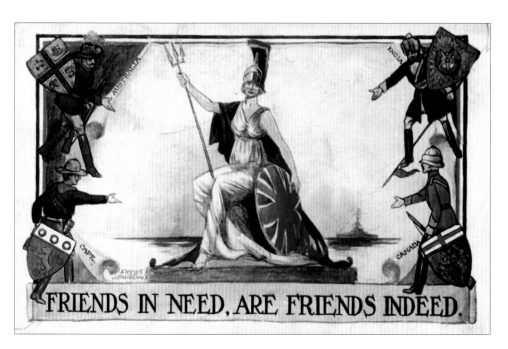

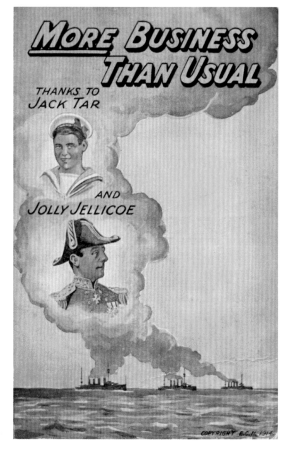

Top: Australia, India, the Cape (South Africa) and Canada feature on this patriotic card, 'Friends in Need, are Friends Indeed'. *Lower:* A pair of naval-inspired cards with Jack Tar alongside 'Jolly' Jellicoe.

ANSWER THE CALL

OF
THE

LONDON RIFLE BRIGADE

130 BUNHILL ROW E C
OR
WINCHESTER HOUSE OLD BROAD ST E C

2ND CITY OF LONDON BATTALION
ROYAL FUSILIERS

Recruiting Office,
THE ARMOURY, 9, TUFTON STREET,
WESTMINSTER, S.W.

RECRUITS REQUIRED AT ONCE
TO COMPLETE THIS FINE BATTALION.
UNIFORM & NECESSARIES IMMEDIATELY ON ENLISTMENT.
ARMY RATES OF PAY & ALLOWANCES.

GOD SAVE THE KING.

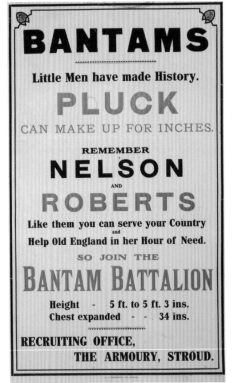

BANTAMS

Little Men have made History.

PLUCK

CAN MAKE UP FOR INCHES.

REMEMBER

NELSON

AND

ROBERTS

Like them you can serve your Country
and
Help Old England in her Hour of Need.

SO JOIN THE

Bantam Battalion

Height - 5 ft. to 5 ft. 3 ins.
Chest expanded - - 34 ins.

RECRUITING OFFICE,
THE ARMOURY, STROUD.

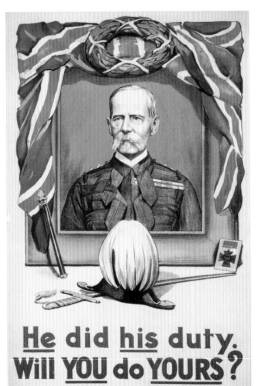

He did his duty.
Will YOU do YOURS?

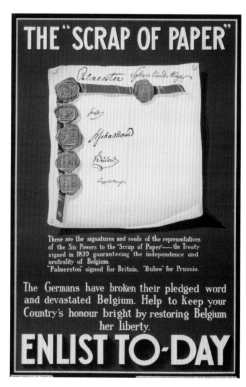

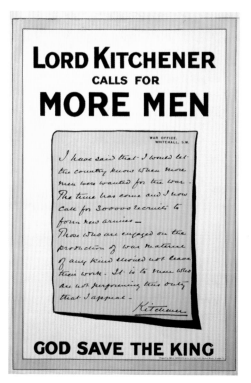

Unlike in Germany, conscription was not introduced in Britain until the beginning of 1916. Until then the Army consisted of the regulars and a large contingent of volunteers. The message of the recruiting posters varied widely, from the political, as shown above, to the general sense of doing one's duty to King and Country.

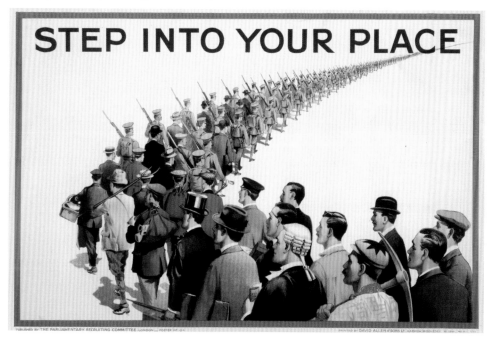

What in the end will settle this war ?

TRAINED MEN

It is

YOUR DUTY

to become one

PUBLISHED BY THE PARLIAMENTARY RECRUITING COMMITTEE, LONDON.—POSTER No. 94. PRINTED BY JAS. TRUSCOTT & SON, LTD., SUFFOLK LANE, LONDON, E.C.

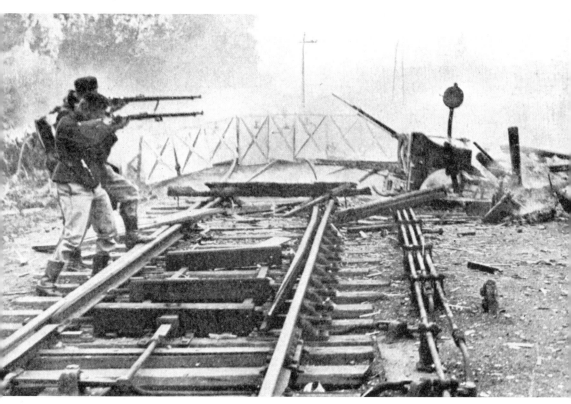

Belgian troops. *Above:* Impeding the Germans. *Below:* 'Nearing the scene of battle, they pay little attention to smartness of dress, but are none the worse for that when it comes to fighting.'

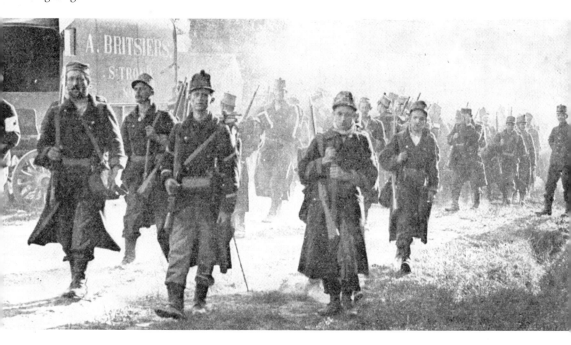

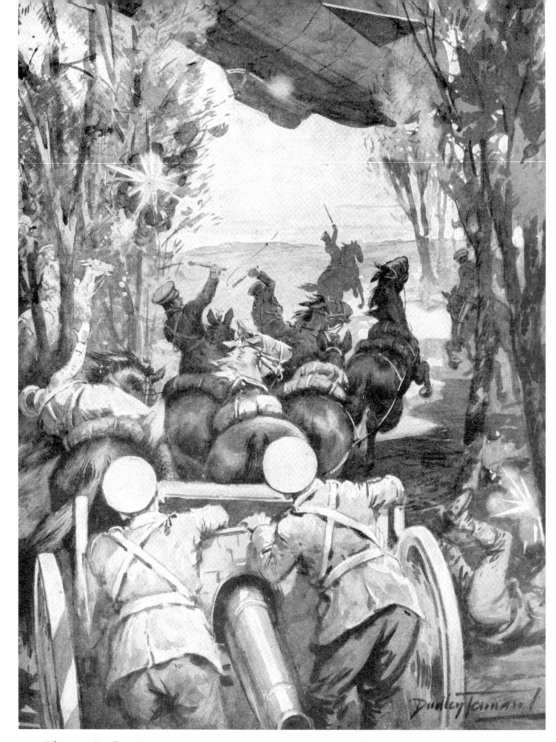

The war in the air

Built by the Zeppelin company, the LZ-28 was launched in September 1914 and renumbered by the German Navy as L5. The following year the L5 was near the Russo-German border when it was shot at by a Russian horse battery and, leaking hydrogen gas, it was brought down near woods, damaged beyond repair. The German officers and crew of the Zeppelin were taken prisoners by the Russians.

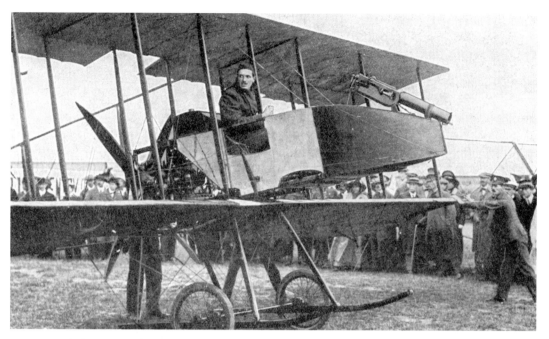

New fighter aircraft

The earliest aircraft participating in the First World War were crude machines, mostly adapted from civilian models, although several new purpose-built machines soon emerged from the major manufacturers. This was the first, a Vickers FB.5, known as the 'Gunbus', a two-seater biplane equipped with a Lewis gun operated by the observer in the front nacelle. At least with this pusher-type the propeller is well away from the gun. *Below:* Landing a Royal Aircraft Factory RE.5 fuselage from a British transport ship. Six of these reconnaissance biplanes were deployed to France in September 1914.

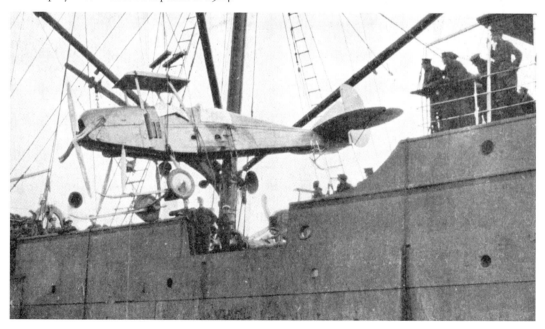

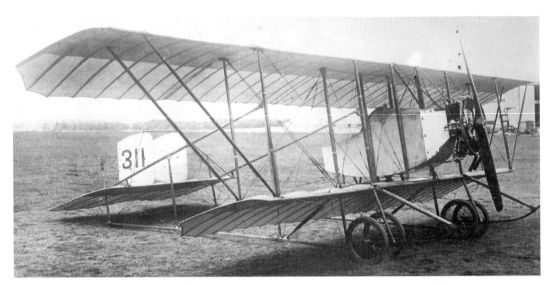

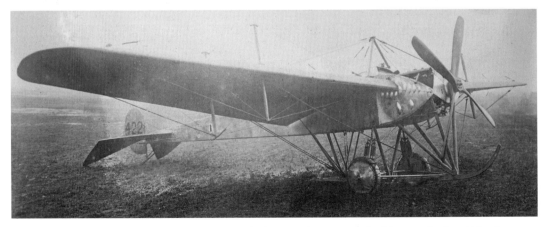

The war saw a rapid acceleration in aircraft design. This group, all photographed at Aldershot in 1912, is representative of the British Army's pre-war machines. *From the top:* Gaudron G2 biplane, and Blériot and Brooklands Flanders monoplanes.

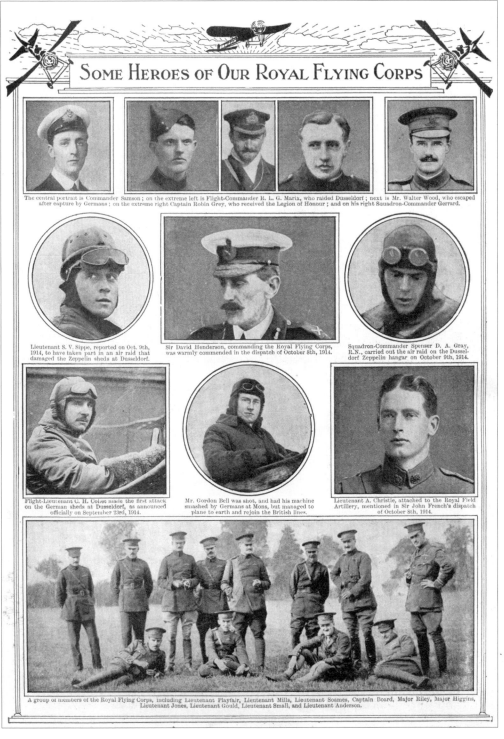

SOME HEROES OF OUR ROYAL FLYING CORPS

The central portrait is Commander Samson; on the extreme left is Flight-Commander R. L. G. Marix, who raided Dusseldorf; next is Mr. Walter Wood, who escaped after capture by Germans; on the extreme right Captain Robin Grey, who received the Legion of Honour; and on his right Squadron-Commander Gerrard.

Lieutenant S. V. Sippe, reported on Oct. 9th, 1914, to have taken part in an air raid that damaged the Zeppelin sheds at Dusseldorf.

Sir David Henderson, commanding the Royal Flying Corps, was warmly commended in the dispatch of October 8th, 1914.

Squadron-Commander Spenser D. A. Gray, R.N., carried out the air raid on the Dusseldorf Zeppelin hangar on October 9th, 1914.

Flight-Lieutenant C. H. Collet made the first attack on the German sheds at Dusseldorf, as announced officially on September 23rd, 1914.

Mr. Gordon Bell was shot, and had his machine smashed by Germans at Mons, but managed to plane to earth and rejoin the British lines.

Lieutenant A. Christie, attached to the Royal Field Artillery, mentioned in Sir John French's dispatch of October 8th, 1914.

A group of members of the Royal Flying Corps, including Lieutenant Playfair, Lieutenant Mills, Lieutenant Soames, Captain Board, Major Riley, Major Higgins, Lieutenant Jones, Lieutenant Gould, Lieutenant Small, and Lieutenant Anderson.

Formed in 1912, the Royal Flying Corps was the air arm of the Army until it merged with the Royal Naval Air Service in April 1918 to become the Royal Air Force.

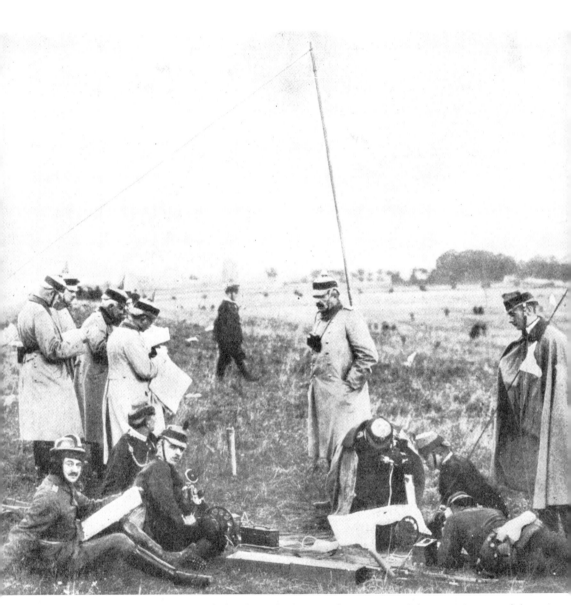

One of the most important roles for the embryonic air forces was aerial reconnaissance of the battlefield. *Above:* a company of German 'air scouts', receiving telephone instructions from base. The leather-helmeted figure on the left is an observer with his map board.

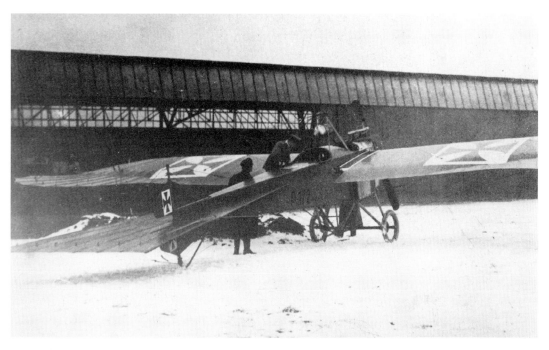

A late 1914 German Taube monoplane, above, and German 'aviator officers' in front of an Albatross B.II biplane.

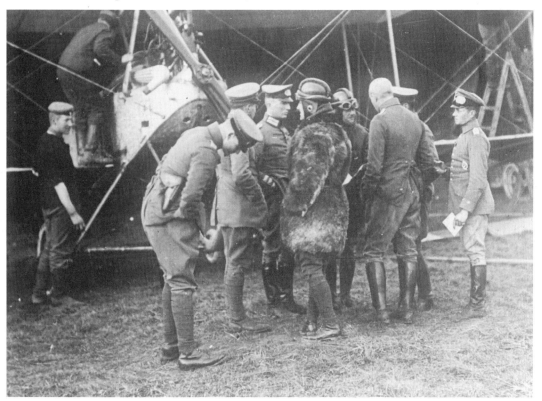

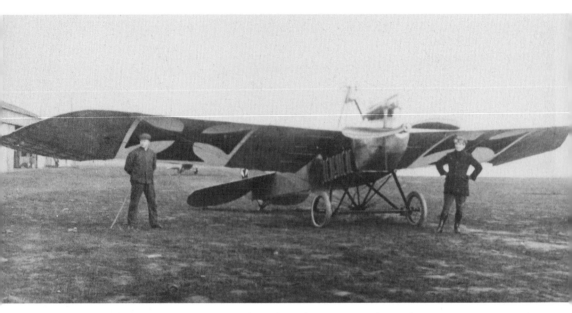

A German Halberstadt Taube monoplane from late 1914. *Below:* The Russian Minister of War poses in front of this large four-engine Sikorsky Ilya Muromets S-22 biplane. The central figure in the bowler hat is the inventor, Igor Sikorsky. The Ilya Muromets was developed as a commercial airliner and first flew in 1913, however it also served as a heavy-bomber during the war.

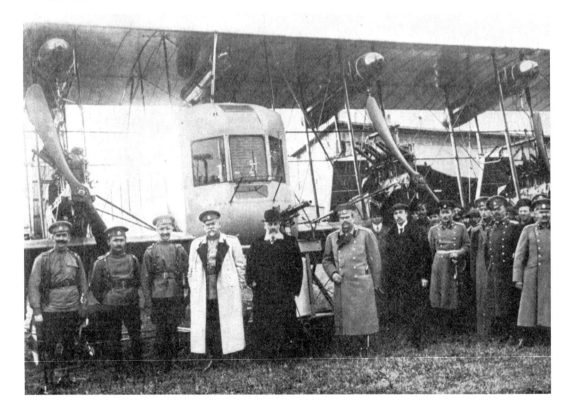

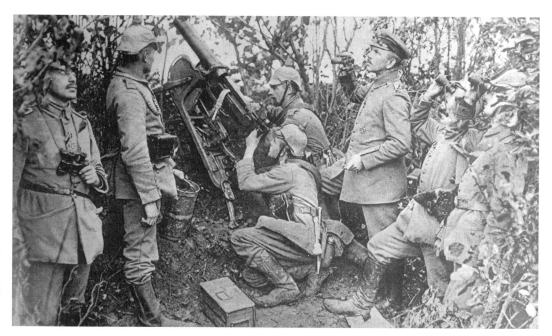

The ascendancy of the flying machines necessitated new countermeasures. The most basic was to elevate conventional machine guns to attack low-flying aircraft. These are German gunners. Below is an early example of a German vehicle modified with an anti-aircraft gun mounted at the rear. Note the storage for the shells beside the driver's position

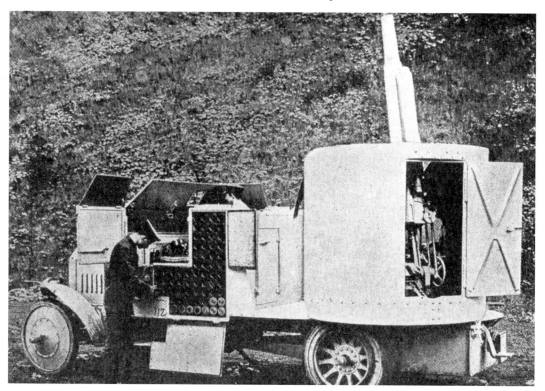

Hogue, Cressy, Aboukir – a major defeat for Britain

While the British had spent an absolute fortune, millions of pounds per ship, building Dreadnoughts, the cruisers and destroyers had been neglected. On the morning of 22 September 1914, the three elderly cruisers *Hogue, Cressy* and *Aboukir* were patrolling the eastern end of the English Channel and the North Sea, when they were attacked by the submarine U-9, captained by Otto Weddingen. The destroyer escort had been forced to seek refuge in Harwich due to bad weather, when Weddingen, on a mission to sink transports off Ostend, spotted the three ships. At 06.20 he fired a torpedo, hitting *Aboukir*. Within twenty-five minutes *Aboukir* had capsized and was sinking. *Hogue* pulled alongside to rescue the crew, while *Cressy* was ordered to search for the U-Boat. *Hogue* was hit as *Aboukir* capsized, two torpedoes striking the fatal blow. She sank at 07.15. *Cressy* tried to ram the sub but missed and then continued the rescue effort. Soon, she too was hit, and sank. 1,455 men lost their lives that morning, with 837 rescued by Dutch trawlers and the destroyer escort, which finally arrived around 10.45.

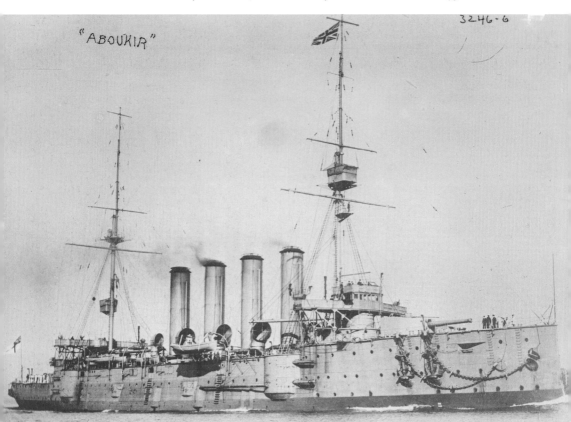

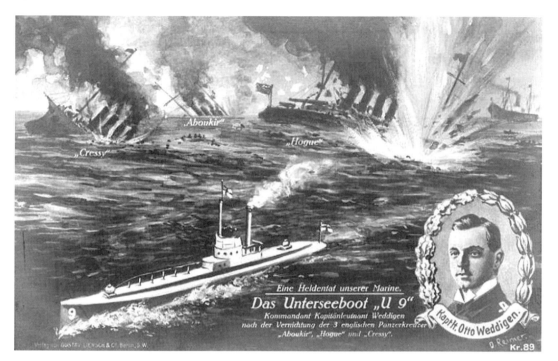

Above: A German propaganda postcard showing the sinking by U-9 of the *Hogue, Cressy* and *Aboukir. Below:* Otto Weddigen returned to his base in Wilhelmshaven, Germany, to a hero's welcome.

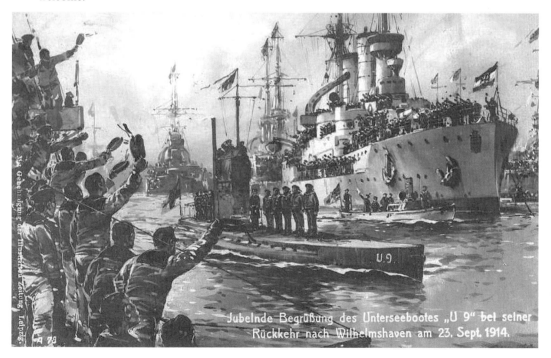

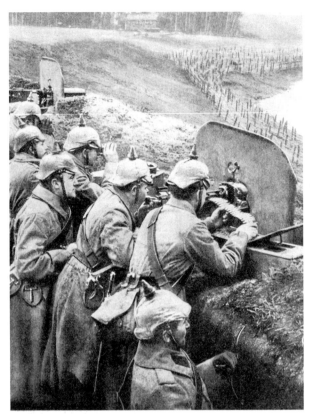

The Eastern Front

Peering into the distance to observe the advancing enemy, these German troops are in a position strongly defended by barbed wire entanglements. The original caption was, 'An incident of the campaign in East Prussia.' In 1914 the Russian army had invaded East Prussia and occupied a significant portion of Austrian-controlled Galicia in support of the Serbs and their allies, the French and British. *Below:* A Russian Maxim gun team at the outbreak of the war.

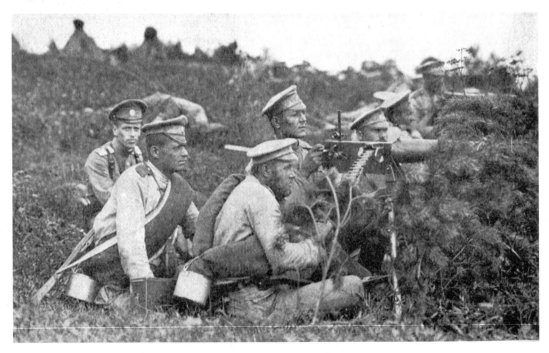

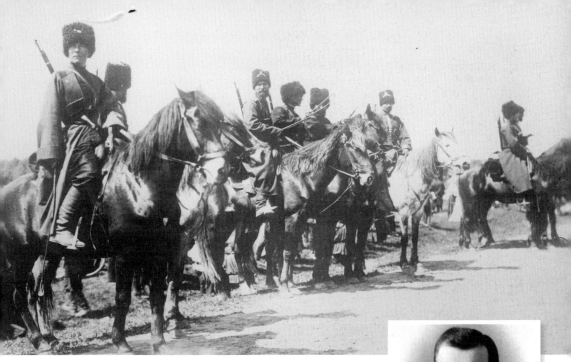

Tsar Nicholas II, the last Emperor of Russia, had hoped to broker a peace with the Kaiser, his first cousin as with Britain's King George V. However, unwilling to abandon Serbia, he put his army on alert and on 31 July completed its mobilisation. With Russia refusing to comply with Germany's demands to stand down, the two nations went to war on 1 August 1914. The Tsar's army was famously known as the 'Russian Steamroller', but in truth it was woefully unprepared for war. Nonetheless, the Russians had opened up a second front and in doing so had raised the war to a global conflict. The Russian Cossacks are shown above, with Russian infantry below.

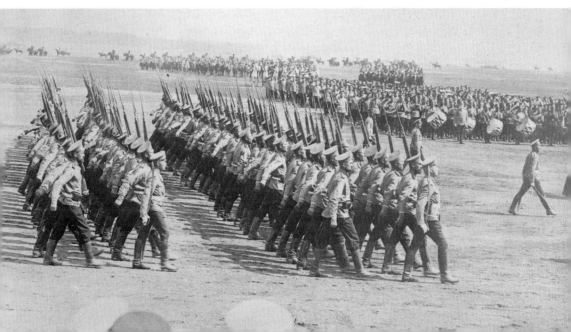

Two faces of war. *Above:* German prisoners burying their dead near Reims in October 1914. *Below:* An improvised band of German troops entertaining the inhabitants of a village in an occupied region of Russian Poland.

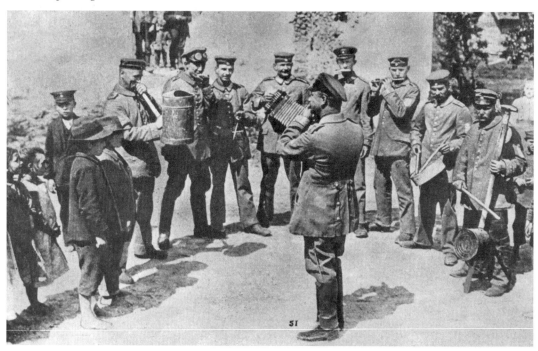

OCTOBER 1914

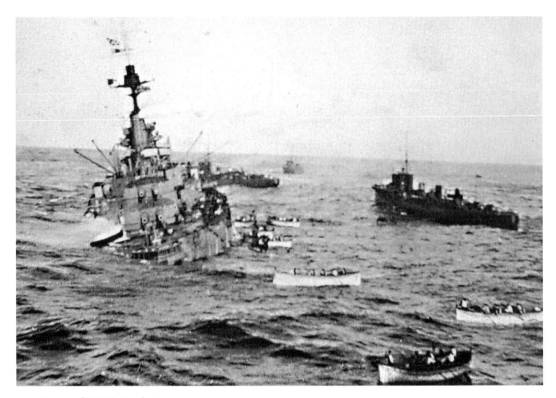

Loss of HMS *Audacious*

The King George V-class battleship HMS *Audacious* was launched at Cammell Laird's Birkenhead shipyard on 14 September 1912. She was 598 feet long and had ten 13.5-inch guns. Off the coast of Ireland, on 27 October 1914, she hit a German mine and began to list. The transatlantic ocean liner RMS *Olympic*, sister to the *Titanic*, was close by and helped in the rescue of the crew. *Below:* Viewed from the *Olympic*, this side view shows the lifeboats of the liner rescuing some of the 900 crew of *Audacious*. Despite the large number of Americans aboard, the Admiralty tried to put a news blackout in force. It probably fooled no one.

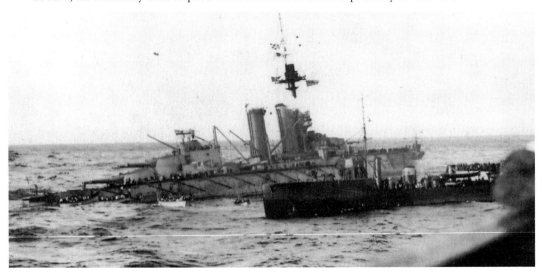

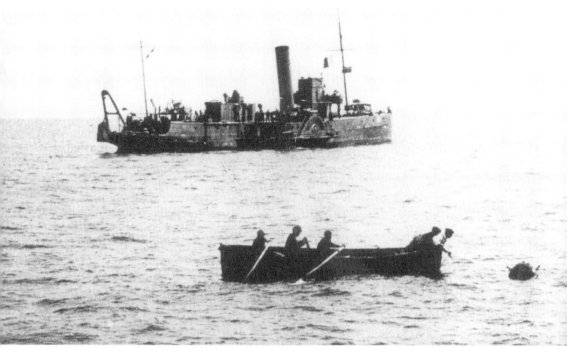

Mines were a constant hazard. This view shows the dangerous job of clearing mines. With their paddle minesweeper at a safe distance, the crew of the whaler are pulling the mine towards themselves so they can defuse it. Not the kind of job the recruiting officer would have told you about as you signed up for the duration.

Below: Many railway and other ferries were called up for war service. This view is of one of the Isle of Man Steam Packet Co.'s paddle steamers as a minesweeper. Paddlers were ideal for this because of their maneuverability.

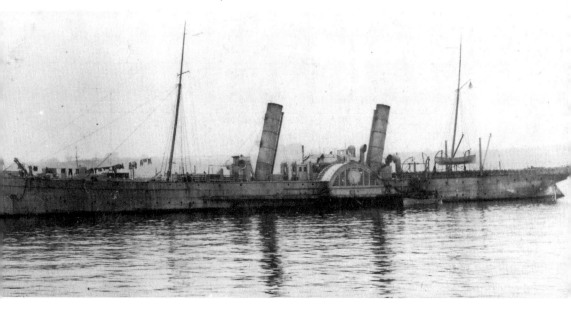

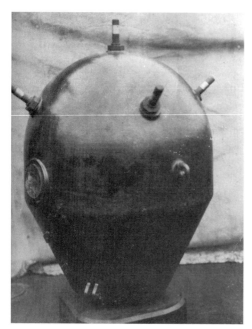

The scourge of the seas: a German mine close up. The Germans could lay these from converted merchant ships and destroyers, and latterly from specially designed submarines. Indiscriminate in their use, they caused untold damage to ships, closed major shipping lanes and created havoc wherever they were laid.

Below: A German minesweeping crew taking care of a British mine.

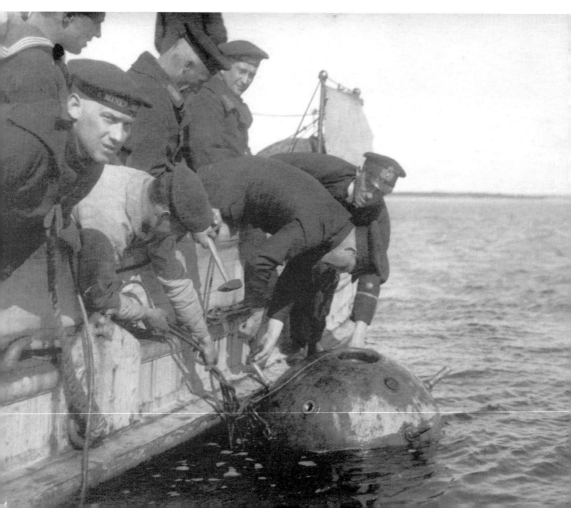

A British minesweeper in the Bristol Channel. Taken up from service, this paddler would have spent the summer of 1914 taking holidaymakers on pleasure trips. By September, it was searching for mines in the Bristol Channel.

Below: HMS *Donegal* was a Monmouth-class cruiser built in 1903 at Fairfield's in Govan, Glasgow. Her main armament was fourteen 6-inch guns. She was assigned to the African Station and spent 1914 off Sierra Leone, protecting British trade routes. She was scrapped in 1920. This view shows her around 1917, when painted in Norman Wilkinson's dazzle paint scheme.

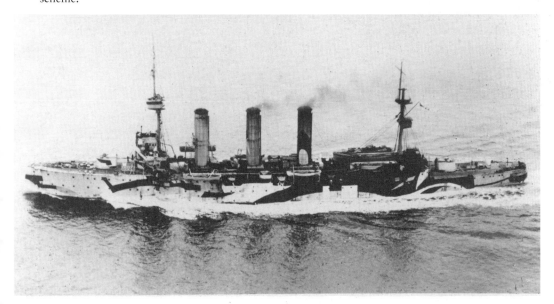

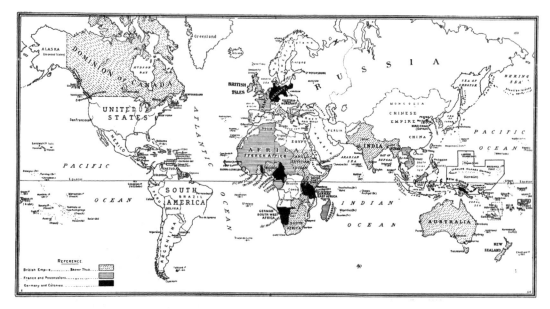

A map of the world. British, French and German Possessions before the start of the war in 1914.

Rallying the Empire

The First World War came at a time when the sun never set on the British Empire and Britain's declaration of war had also committed the colonies and Dominions to provide military, financial and material support. Over 2.5 million men served in the armies of the Dominions and played a significant part in the military campaigns, in particular the Canadian troops at Vimy Ridge, and both the Australians and New Zealanders during the Gallipoli campaign against the Ottoman Empire in the Dardanelles in Turkey. The death tolls of the major participating countries read with shocking inevitability. India tops the table with 74,000 men lost, then comes Canada with nearly 65,000, Australia with almost 62,000, New Zealand 18,000 and South Africa with around 9,500.

As with so many aspects of life, the First World War brought great change and many commentators regard it as a turning point in the fate of the Empire nations, igniting a spark that engendered a greater sense of independent identities.

Troopships

By October 1914, the first Canadian troops had arrived in Plymouth. In the very first convoy of the war, a fleet of requisitioned passenger liners brought many thousands of Canadian soldiers to Britain. It was, at the time, the largest single movement of troops worldwide. In the same month, some 50,000 Anzac troops left Australia and New Zealand for Britain and France, arriving in November 1914.

The 48th Highlanders (Canadian) leaving Toronto before embarking for Europe and, below, marching through the streets of London. In September 1914 the Prime Minister had stated: 'Our self-governing Dominions demonstrated, with a spontaneousness and unanimity unparalleled in history, their determination to affirm their brotherhood with us, and to make our case their own.'

CANADA'S SPLENDID RALLY TO THE FLAG

GROUP OF CANADIAN OFFICERS, WITH COLONEL SAM HUGHES SEATED IN THE CENTRE.

THE 48TH HIGHLANDERS (CANADIAN) LEAVING TORONTO BEFORE EMBARKING FOR EUROPE.

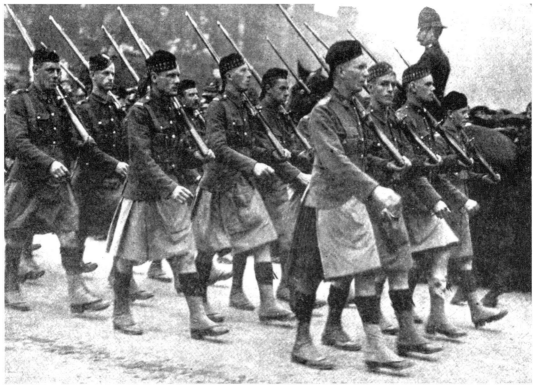

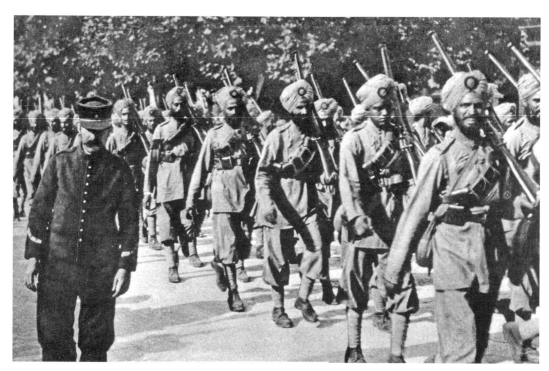

The call to the Empire was answered not only by Canada, Australia, New Zealand, South Africa and Newfoundland, but also by India, whose troops are shown after disembarking in Marseilles at the end of September 1914. Lord Roberts had died after visiting the Indian soldiers at the Front. *Below:* Gurkha troops detraining in France.

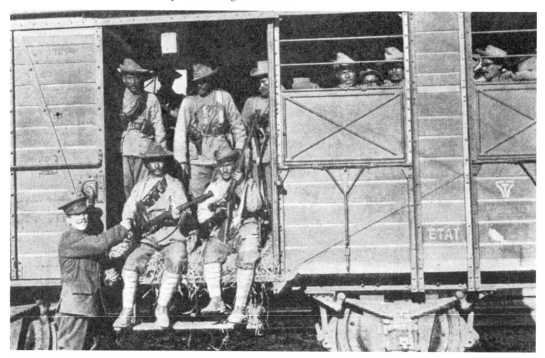

The Kaiser was also able to call upon Germany's foreign colonies. *Above:* Germany's colonial army as represented by a cavalry contingent in German South-West Africa.

Below: Other nations also had their foreign territories. This is an encampment of French-Morrocan 'spahis' at Ribecourt in northern France.

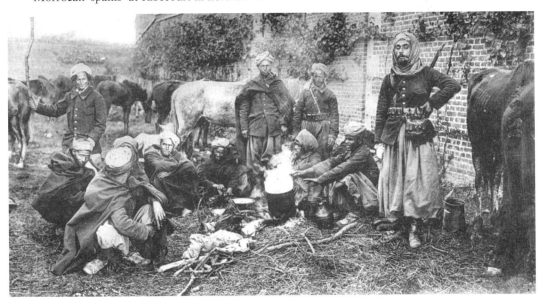

Submarine warfare

Submarines would play a huge part in the war. Despite being invented in the 1870s, the torpedo had not really been proved in service until the Russo-Japanese War of 1905. Britain's first submarines, the Holland-class, were built in Barrow-in-Furness in 1902–3. Barrow has become synonymous with submarine construction. The next class to follow was the A-class, of which thirteen were built, and then the B-class shown here. The eleven B-class submarines could travel at 13 knots, and displaced 280 tons. Completed between 1905 and 1906, they proved reliable performers. Of the eleven, one was sunk in 1912 and another bombed in dock in Venice in 1916. The others survived the war to be scrapped between 1919 and 1922.

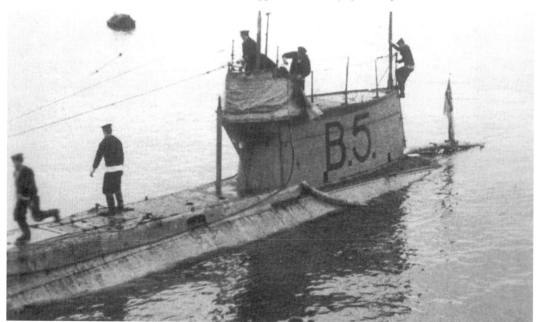

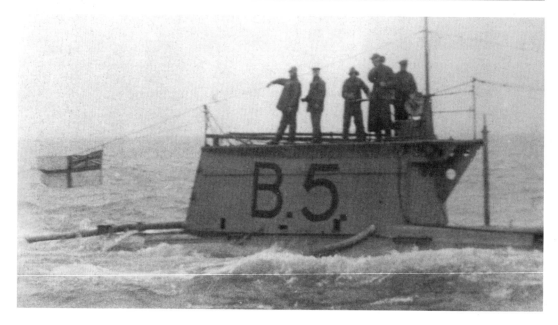

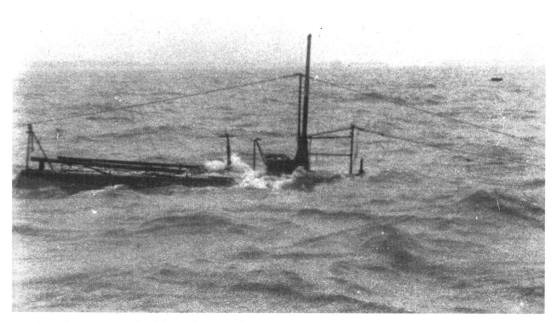

B4 submerging. Each of the B-class vessels had a compliment of sixteen and was fitted with two 18-inch bow torpedo tubes. 13 knots was possible on the surface and 7 knots when submerged. *Below:* Whitehead torpedoes being loaded at Portsmouth. These tin fish were developed in Austro-Hungary by Whitehead, which sold rights to Germany and the UK to manufacture torpedoes.

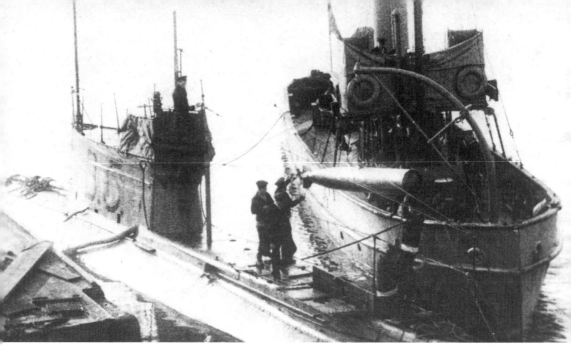

Using a steam drifter, the torpedoes are about to be loaded aboard this B-class submarine, above. The view from a periscope was rather unique and, while submerged, it was the eyes of the submarine. The officer would have to take all sorts of measurements of his target's speed and direction, before a firing solution was calculated and the torpedo fired ahead of the ship it was to hit. If everything was calculated correctly, a minute or so after firing, a hit would be heard. A torpedo had a range of some 10,000 yards and a speed of around 40 knots.

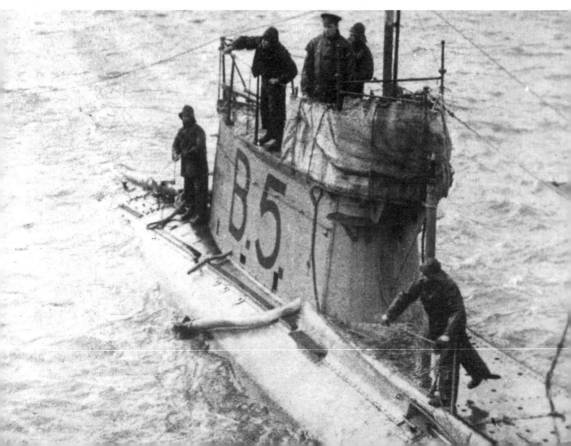

NOVEMBER 1914

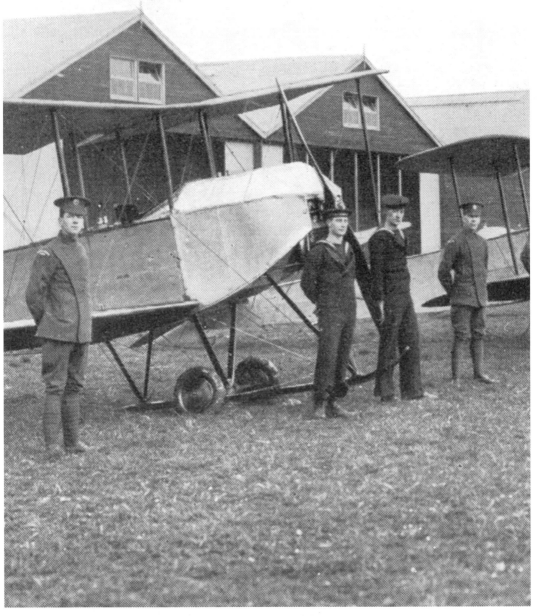

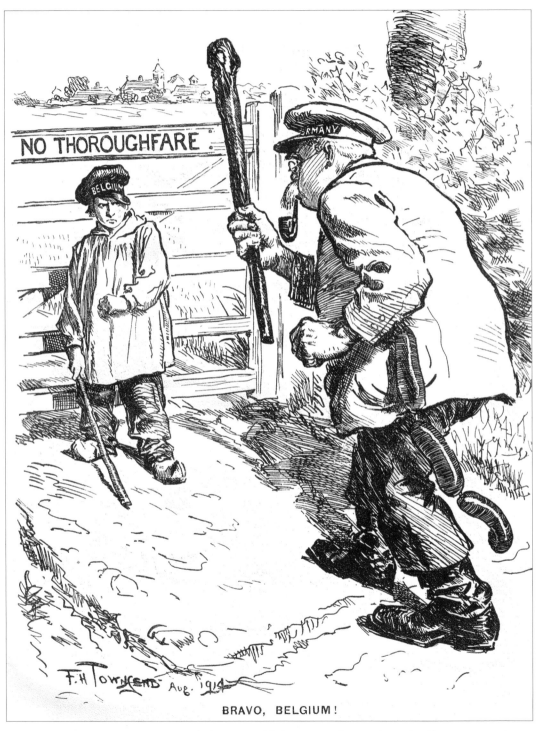

BRAVO, BELGIUM!

Punch cartoon, published in October 1914. 'The Prussian Bully invades an inoffensive Neutral Country.' It is an image that was rappropriated twenty-five years later at the start of the Second World War, only with Hitler as the bully.

Germans behaving badly

The British press was always eager to publish photographs which put the Germans in a poor light. *Above:* German officers with their sergeant-major sit discussing orders for the following day. 'Not unnaturally they have made free of the cellars of the Belgian café in the background.' *Below:* 'Many of the French and Belgian churches which had not been destroyed by shell fire were used by the Germans as barrack rooms. In this church somewhere in Northern France the invaders have made themselves extremely comfortable.'

German soldiers getting water at Vise, Belgium. *Below:* Escorting a group of British prisoners.

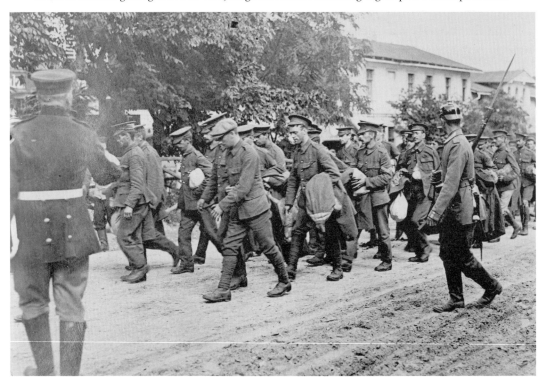

Cameras were seldom permitted at the front, especially in the early stages of the war, and consequently many of the photographs from this time tend to be of scenes behind the lines. *Above:* A German field kitchen and, below, the Germans are shown dolling out food to the poor of Bruges. It appears to cast the 'invaders' in a better light, but the original caption puts us straight. 'In many Belgian towns the Germans commandeered all the provisions in the shops and warehouses, thereby cutting off food supplies from the people, to whom they then gave meagre daily allowances so as to keep them alive.'

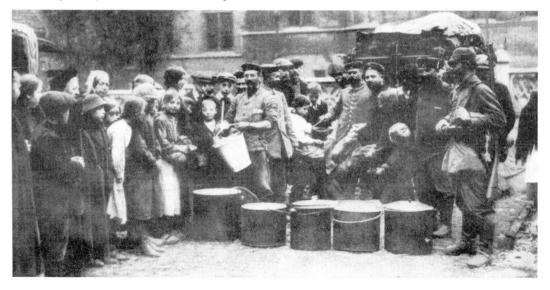

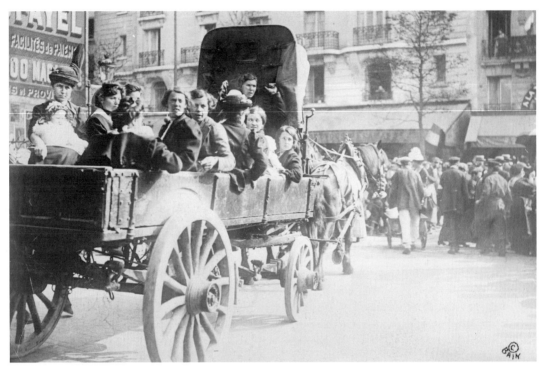

Above: Refugees fleeing from Belgium arrive in Paris. *Below: Punch* cartoon published in October 1914 under the title 'Unconquerable'. The Kaiser. 'So, you see – you've lost everything.' The King of the Belgians. 'Not my soul.' The image by Louis Raemaekers, below right, has a simple caption, 'Belgium'.

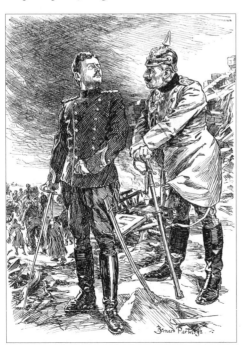

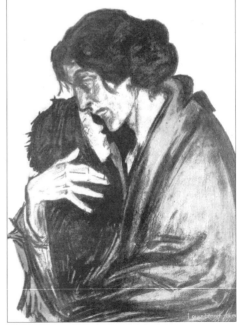

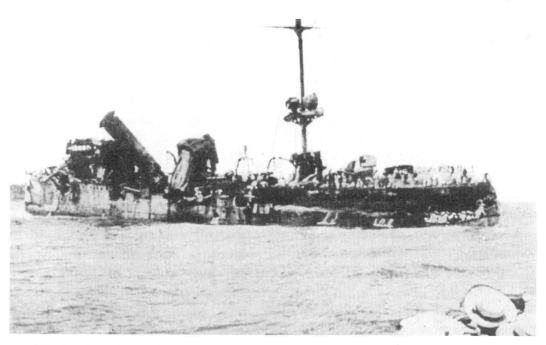

The Battle of Cocos

On 9 November 1914, the Battle of Cocos took place. The Dresden-class cruiser SMS *Emden* had been loose in the Indian Ocean since she had left Tsingtao, the German treaty port in China. She had shelled Madras, attacked Penang and had sunk twenty-five merchant vessels as well as two navy ships in Penang itself. Despite trying to silence the radio station at Cocos Island, the British sent a warning message and soon the Australian HMS *Sydney* was on her way. She dispatched *Emden* on the afternoon of the 9th with the loss of 134 of the *Emden*'s crew.

Below: The *Sydney* returned to Trincomalee, where she is seen with the *Carmania*, the Cunard liner that sank the *Cap Trafalgar* the previous month.

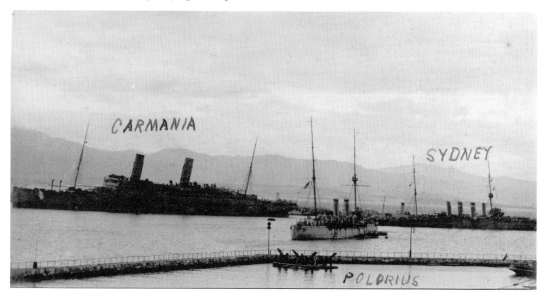

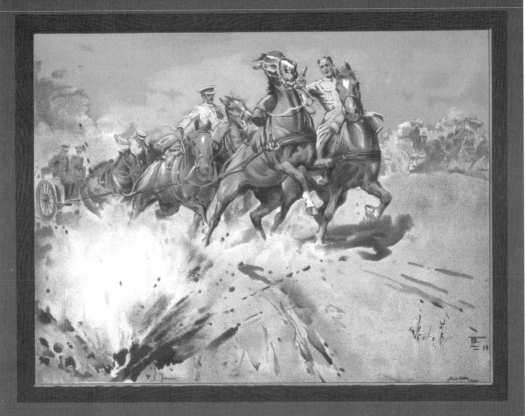

AT THE FRONT!

Every fit Briton
should join our brave men
at the Front.

ENLIST NOW.

The war horses

In the early stages of the war mounted warfare, that vestige of earlier conflicts – in particular the Boer War – was still seen as a viable means of attack. However, the mechanisation of warfare and the efficient dealing out of death by machine guns, resulting in the entrenchment of opposing positions, made the value of the cavalry charge highly questionable to most nations. The high casualties incurred – the German machine gunners would target the horses – didn't deter the British, who persisted with mounted infantry and cavalry offensives throughout the war.

At a time when motorised transport was still very much in its infancy, horses were the most efficient means of pulling the big guns, moving munitions and supplies, and for sending messages, through the difficult and muddy terrain. It has been estimated that in total around six million horses took part in the war, and a million died on the British side alone. To lose a horse was worse than losing a man because men were replaceable. To meet the demand for horses, special breeding programmes were instigated and thousands of horses were confiscated from British civilians. Feeding the horses put an additional strain on the supply train and their waste and rotting carcasses added to the risk of disease. Many of the soldiers developed close bonds with their animals and they were shocked when, at the end of the war, the sudden surfeit saw thousands of horses sold off to the locals, many of them destined for the slaughterhouses.

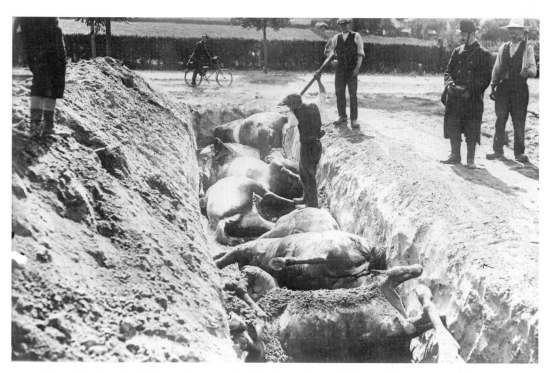

Above: Burying dead horses in a trench following the Battle of Haelen, which was fought on 12 August 1914.

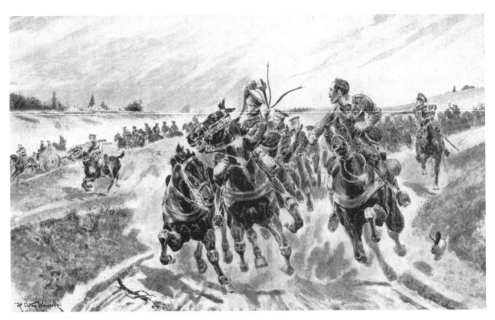

Above: A dramatic wartime illustration of the war horses. 'Bringing up the guns – British artillery getting into position at the Battle of Mons.' The opening stages of the German attack on Mons began on Saturday, 22 August 1914. *Below:* Two posters, one depicting the brave cavalry officer at full tilt, the other promoting the Blue Cross Fund, which, despite the overwhelming statistics, attempted to aid our 'dumb friends'.

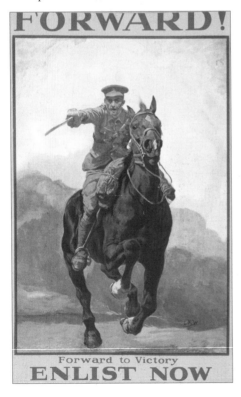

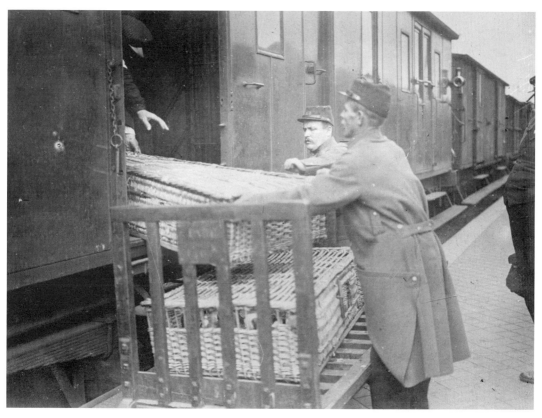

The pigeon post

The horses were not the only animals put to work in the war and carrier pigeons were used extensively. It is estimated that the British used 150,000 birds to take messages.

Above: A consignment of carrier pigeons being unloaded at Dunkirk.

Right: The British Navy's pigeon post. 'A British submarine officer sending a message by carrier pigeon.' The Dickin Medal, introduced in in 1943 for non-human bravery, was later awarded to thirty-two pigeons.

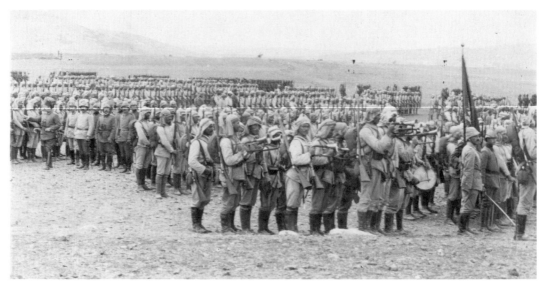

The Force in Egypt

Consisting of personnel from a number of British Empire nations, this was established in 1914 with the objective of protecting the Suez Canal. It consisted of troops from a number of countries. *Above:* Troops muster on the Plain of Esdraelon – better known today as the Jezreel valley in the south of Israel. *Below:* Locals bring food for a contingent of British soldiers.

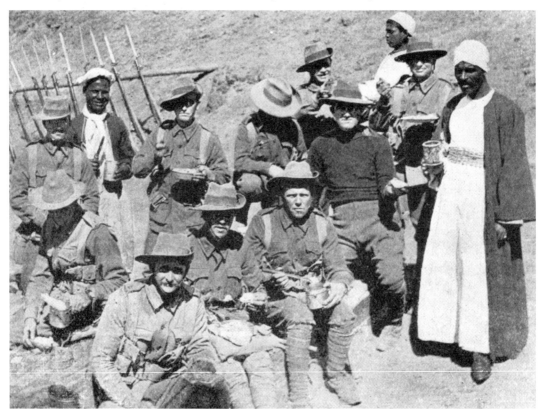

DECEMBER 1914

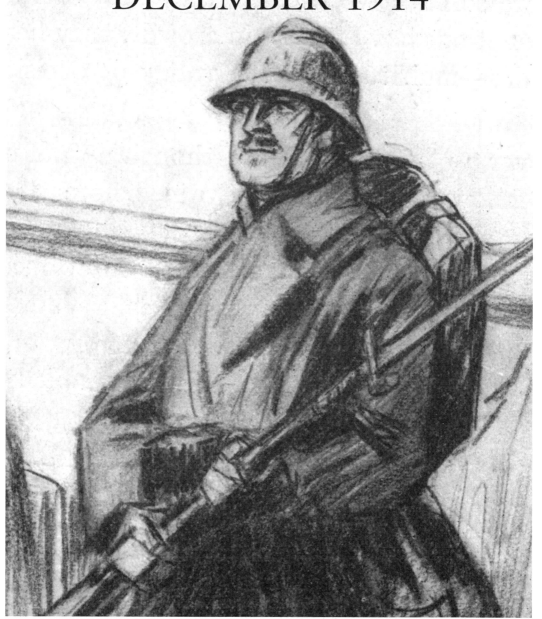

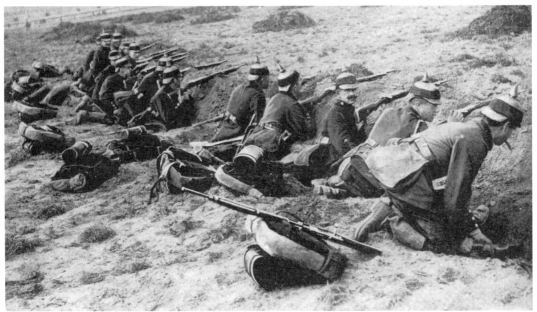

Digging in

In the upper picture, German field guns are being man-handled to reach the brow of a hill. At this stage of the war the ground is still in a reasonably good, and mud-free, condition. The first trenches were shallow, offering a modicum of protection, and were not intended to be permanent. 'Entrenching tools were an essential part of the equipment of all armies. No ground could be held in open country unless the troops made their own cover. The lower photograph shows German infantry advancing and at the first pause obeying the order to dig in.'

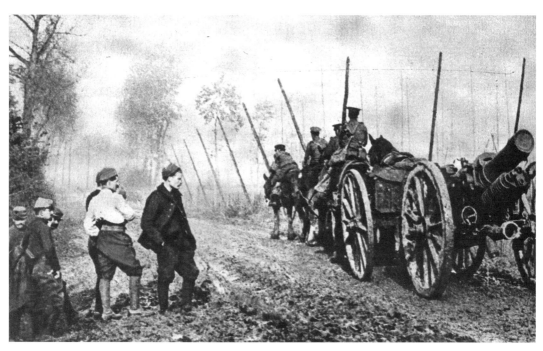

Trench warfare is said to date from the Battle of the Aisne in September 1914, when opposing lines first became locked in the positions, more or less, which they would hold for four years. *Above*: A BEF gunnery team hauls its heavy gun to a new position some miles behind the line. *Below*: The early British trenches were crude affairs, and fairly shallow. But it wasn't long until the practicalities of living and fighting in the trenches was worked out.

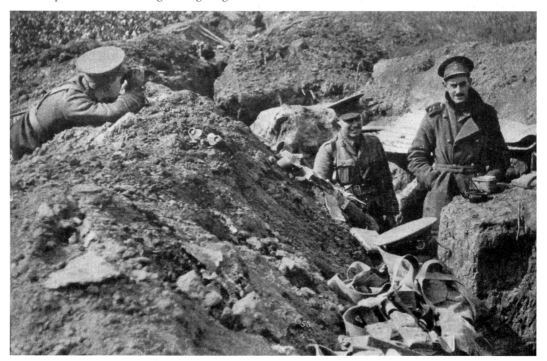

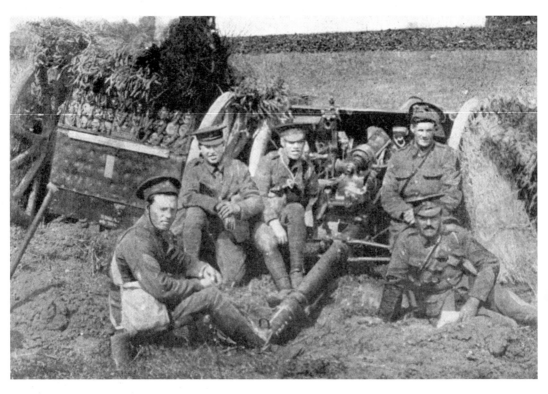

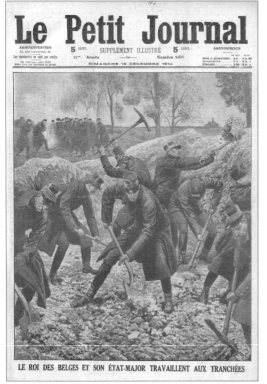

LE ROI DES BELGES ET SON ÉTAT-MAJOR TRAVAILLENT AUX TRANCHÉES

Above: The scene in Belgium, with this field gun scantily concealed from the enemy and entirely unprotected.

Left: Cover of *Le Petit Journal* from December 1914, depicting the Belgian soldiers starting to dig in.

Opposite: The shape of the war to come. These German officers pose in the entrance to a dug-out. Note that they still wear the spiked Pickelhaube, although they are concealed under cloth covers to make them less conspicuous.

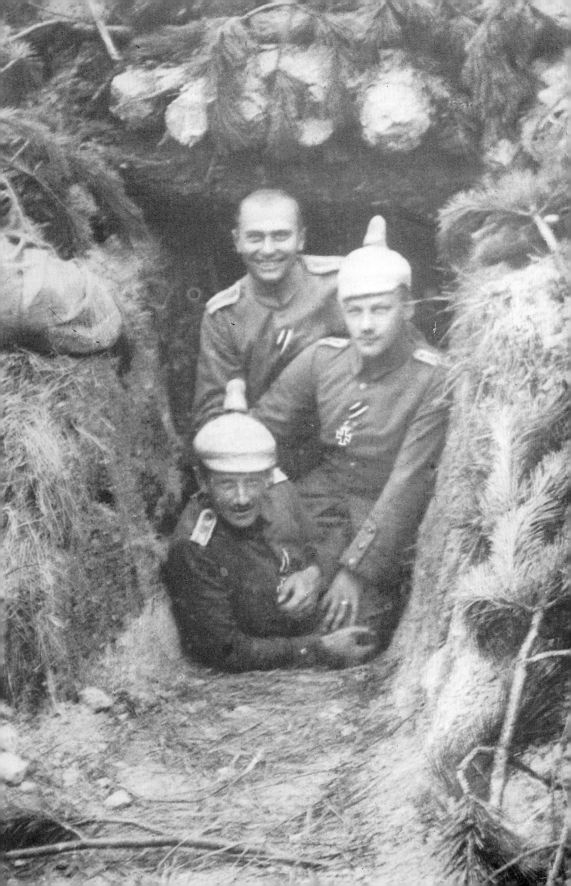

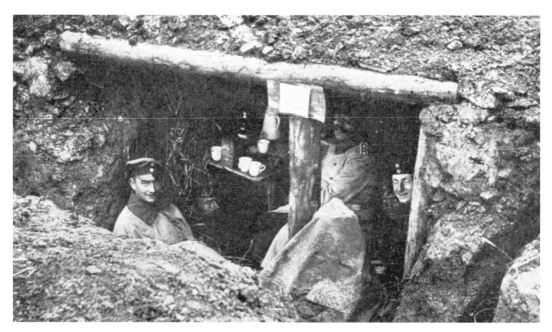

Trench living. Two views from the German trenches. *Above:* German officers enjoy some creature comforts in their 'entrenchment' on the Western Front. *Below:* These German soldiers in Russian Poland take advantage of a break in the fighting to enjoy a game of cards in the autumn sunshine.

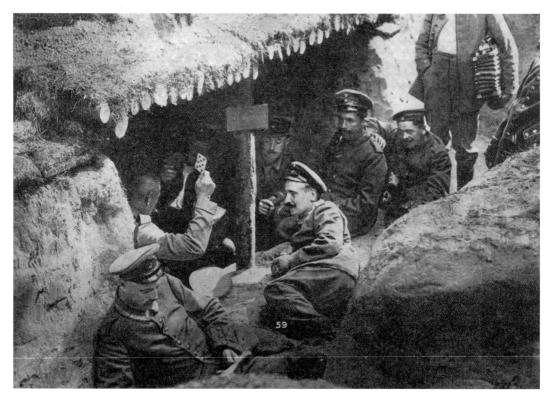

Remember Scarborough!

Those were the words proclaimed on recruiting posters that spread through Britain in December 1914 after the German fleet had taken a sortie down England's coast from Hartlepool to Scarborough, Whitby and East Anglia, bombarding the towns from offshore. These views show part of the damage to parts of Scarborough, from the hole blown in the lighthouse to damaged houses. Even Whitby Abbey was not safe, being damaged in the shelling,

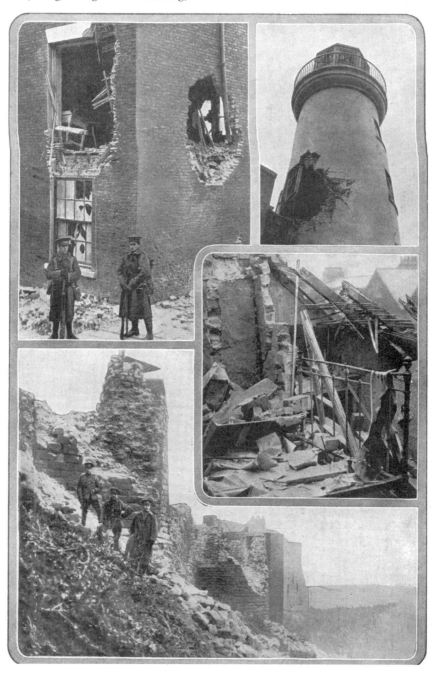

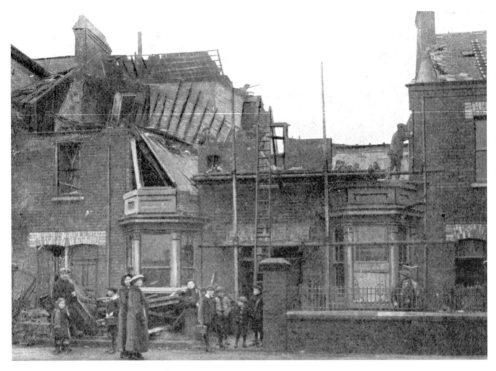

Above: Nos 20 and 21 Cleveland Road, West Hartlepool. The town was attacked at 8.00 a.m. on 16 December. *Below:* Recruiting posters, one depicting the damage at Wykeham Street in Harborough.

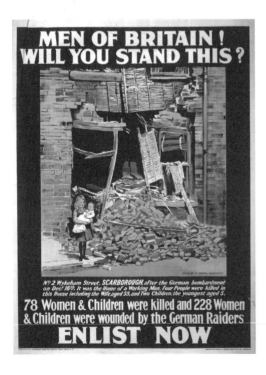

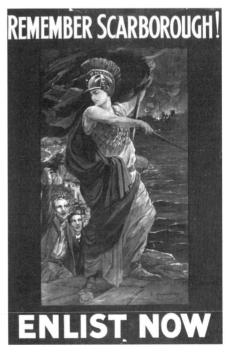

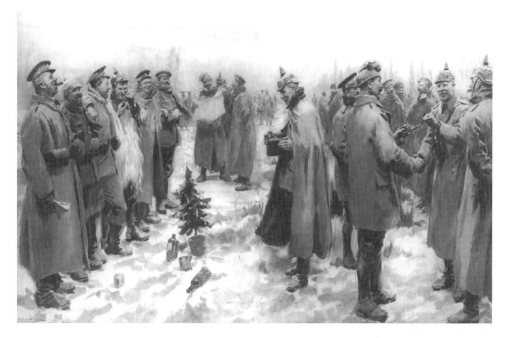

Christmas 1914

In unofficial ceasefires along the Western Front, British and German soldiers exchanged greetings, sang carols and in several places they even took part in impromptu football games. The authorities did not approve of such fraternisation and in subsequent years bombardments were ordered for Christmas Eve to reduce the likelihood of such scenes reoccurring.

Right: The cover of *The Illustrated London News* of 9 January 1915. 'The Light of Peace in the trenches on Christmas Eve. A German soldier opens the spontaneous truce by approaching the British lines with a small Christmas tree.'

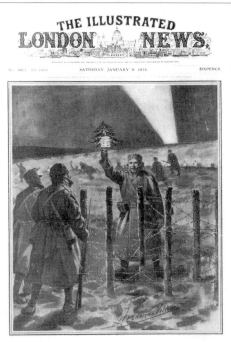

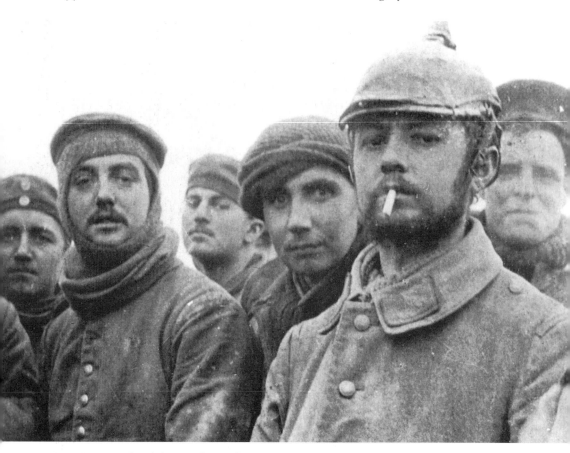

Top: Territorials of the London Rifle Brigade pose with German troops in No Man's Land during the unofficial truce on Christmas Day. *Below: Punch* cartoon published on 23 December 1914. No Christmas dinner for the Kaiser at Buckingham Palace this year!

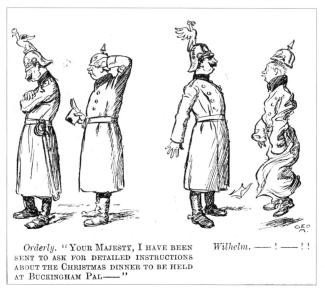

Orderly. "Your Majesty, I have been sent to ask for detailed instructions about the Christmas dinner to be held at Buckingham Pal——"

Wilhelm. —— ! —— ! !

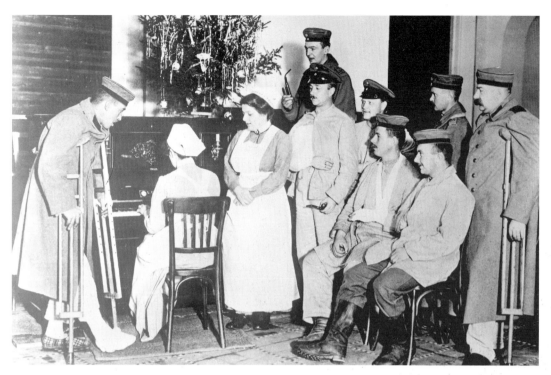

A nurse plays the piano for wounded German soldiers in a hospital in Berlin at Christmas.
Below: On the other side of the Atlantic around six million gifts had been collected for the
children in Europe, taken by the USS *Jason*, which sailed from New York on 14 December.

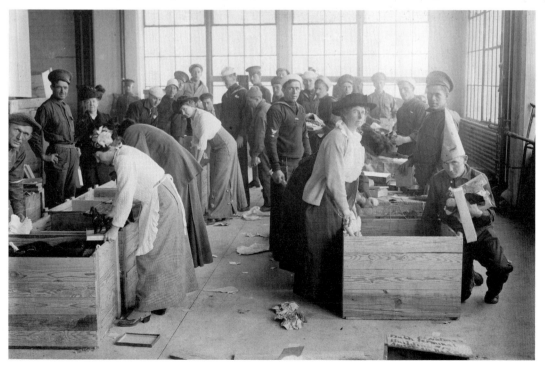

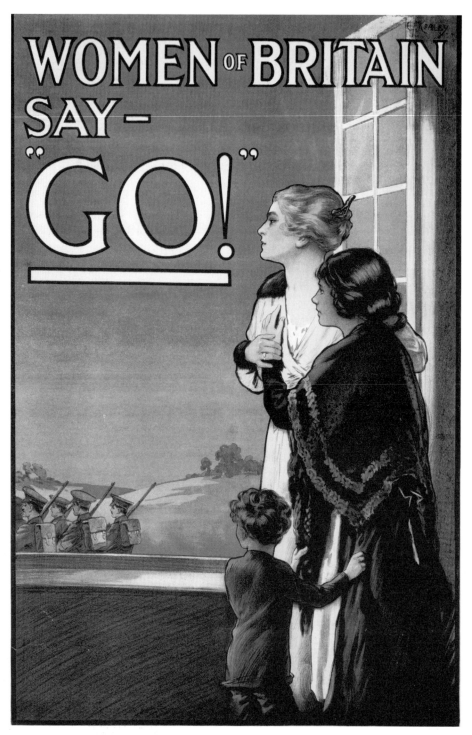

'Off to the Front.' During the war the women did far more than just pack their men off to fight. However, this is a recurring theme of the pre-enlistment recruiting posters at the beginning of the war.

Women at war

In the early stages of the war the women of Britain were regarded with little interest by the establishment. However, the authorities were happy enough to have them act as recruiting agents within the home. They were urged to pack their men off to war, to 'Say GO!' and wave them goodbye. It wasn't just their own men that they cajoled into enlisting either. The white feather movement sprung up with the purpose of publicly humiliating any man who looked, in their eyes, like a shirker, presenting them with a white feather as a mark of cowardice. Men in reserved occupations were not immune to their attentions and a badge scheme was introduced to identify and protect them.

Many women immersed themselves in countless good causes for the war effort, working voluntarily for various charities. But as the war progressed the role of women in society underwent enormous change, and while it is tempting to suggest that the war progressed the cause of the Suffragettes, it is more likely that it probably held back what was only inevitable. Women were not expected to fight, of course, but they marched through London to demand the 'right to serve' in other ways, and as the available man-power on the Home Front began to dwindle while the need for increased production rocketed, it was recognised that women had to fill the gap. Women from all strata of society took on a range of tasks previously undertaken by men. They worked on the buses as 'clippies' and on the trains as porters, they drove ambulances, they worked on the land and, most importantly of all, they reported for work at the munitions factories in their droves. For many women it must have been an enormous transition going from their homes to the noise and bustle of the factories. It was difficult and dangerous work too and handling the TNT used in the manufacturer of shells caused many to become sick with a form of jaundice and some died.

Below: The Right-to-Serve procession through London, July 1915.

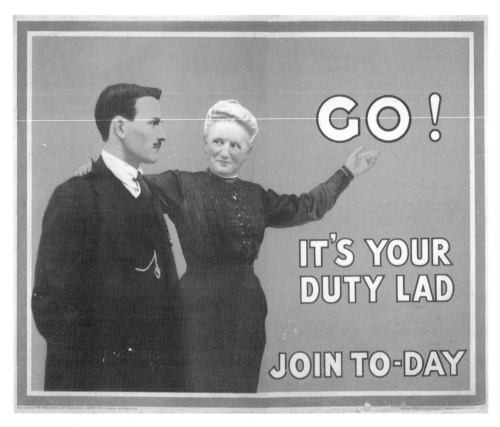

It wasn't just the wives and girlfriends who did their duty. Mothers were also urged to send off their sons, as depicted in the poster above. *Below: Punch* cartoon on the theme of women seeking wartime work.

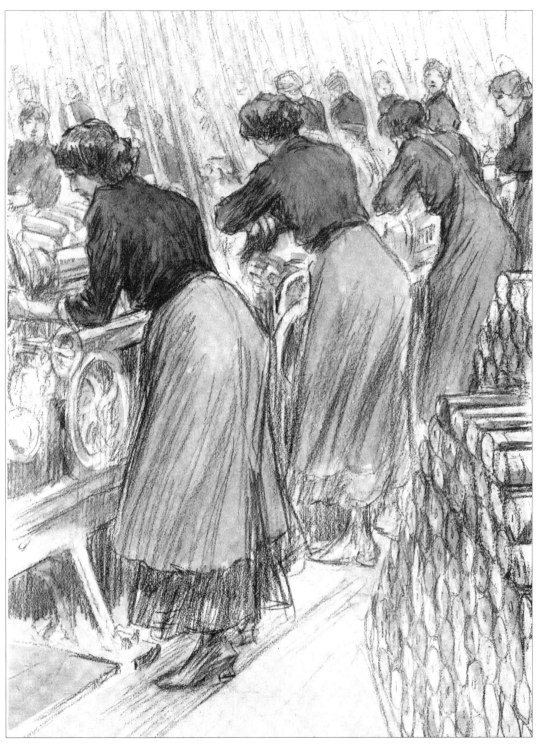

Shell making – munitions work could be very dangerous, for obvious reasons, but there were also considerable health hazards in handling the cordite used in the shells.

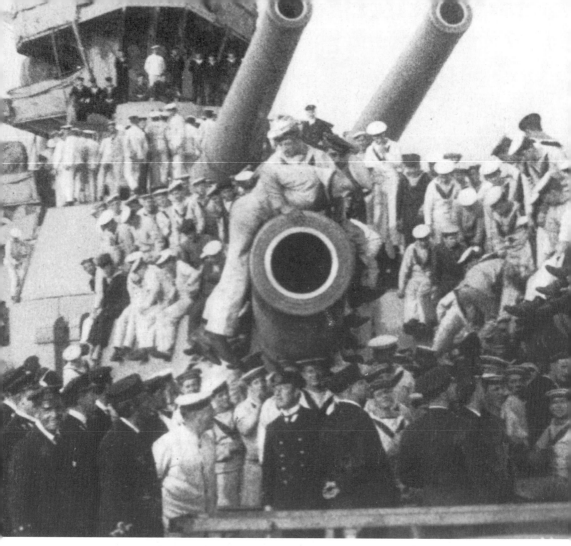

Above: The crew of HMS *Queen Elizabeth* on the fo'c'sle, with many atop the mighty guns.

Dreadnought developments

HMS *Queen Elizabeth* was ordered from Portsmouth navy dockyard in June 1912 and her keel was laid on Trafalgar Day, 21 October. Launched on 16 October 1913, fitting out took much of 1914. In December, she was deployed to the Mediterranean and was involved in the Dardenelles campaign of 1916. In 1918, with Admiral Beatty on board, she took the German High Seas Fleet's surrender. She was one of the Dreadnoughts that would be so badly needed during the war. She was under repair at the time of the Battle of Jutland and returned to service after the battle. *Queen Elizabeth* was one of five of her class, the other vessels being *Warspite*, *Barham*, *Valiant* and *Malaya*, which had all enetered service by February 1916. Four of the class survived both wars, with *Barham* blowing up in 1941. Each was fitted with eight 15-inch guns, twelve 6-inch guns and four torpedo tubes.

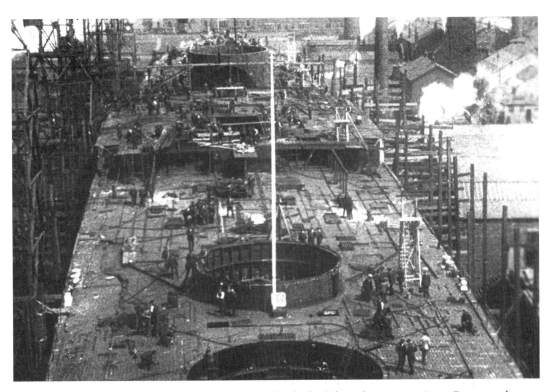

A view looking along the deck of HMS *Queen Elizabeth* while under construction at Portsmouth. The circular holes are for two of her gun turrets. *Below:* A photograph taken before the launch, this view shows the main deck. Some 1,000 crew were needed to operate the vessel.

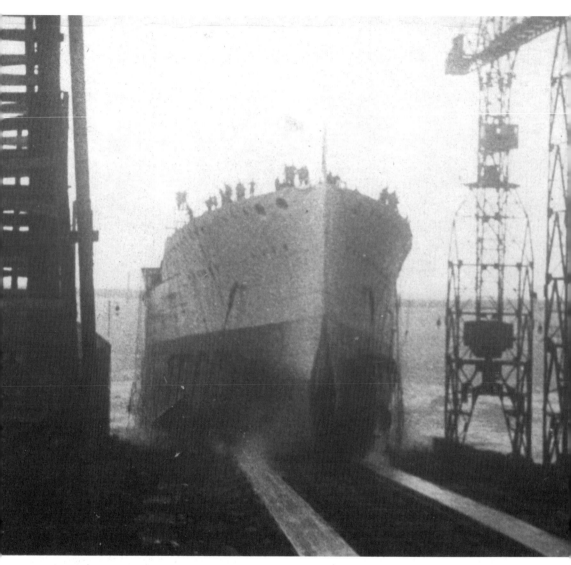

The 31,000-ton ship enters the waters on 16 October 1913. *Queen Elizabeth* was powered by oil-fired steam turbines and had four propellers, giving a top speed of around 25 knots.

Opposite page: The main armament was eight 15-inch guns. Beside each turret, deep in the bowels of the ship, was a magazine, loaded with cordite and shells. Cordite itself was invented to replace gunpowder but could be unsafe. HMS *Vanguard* blew up at Scapa Flow with the loss of over 800 crew as a result of a cordite explosion. Sailors load cordite into the magazine. The shells were separate, with the shell loaded into each gun and then the cordite charge inserted afterwards. Each 15-inch shell weighed nearly a ton.

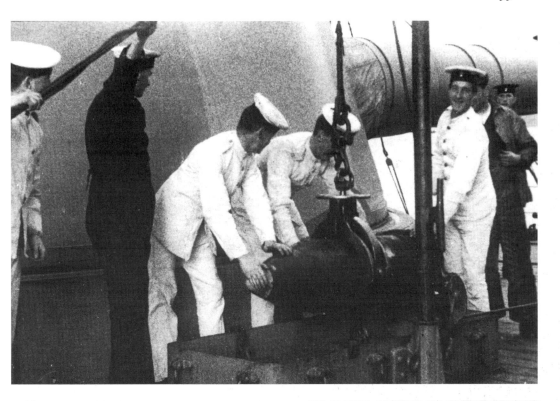

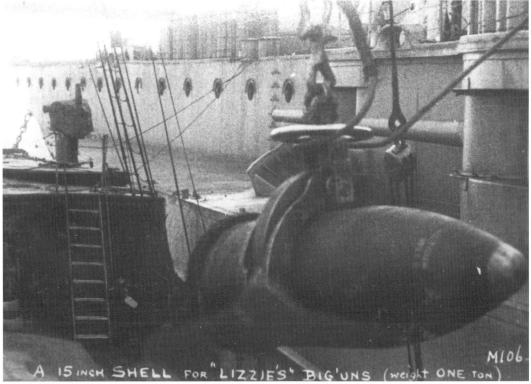

A 15 INCH SHELL FOR "LIZZIE'S" BIG'UNS (weight ONE ton)

M106

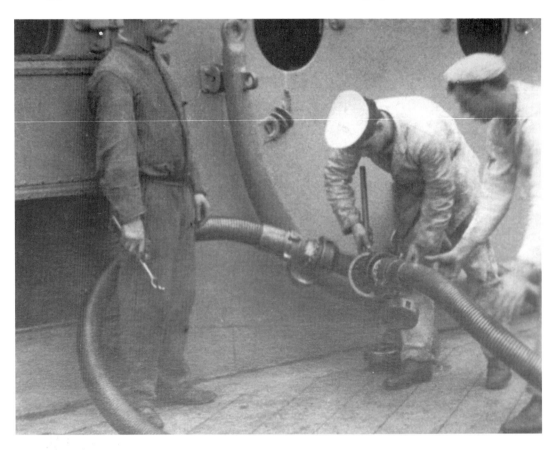

HMS *Queen Elizabeth* was oil-fired. Oil was a relatively new fuel for ships but it came with many advantages. Oil could easily be transported and was much cleaner. It was faster to fuel an oil-fired ship and the ship itself required far fewer men in the engine rooms, with no need for a hundred men or more to feed the boilers. The use of oil did away with the coal hulks or stores of coal which needed to be transferred from mine to ship to store to ship once more.

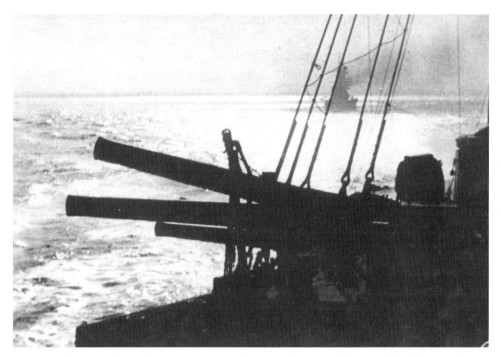

Above: Taken at dusk in the Mediterranean, four of *Queen Elizabeth*'s guns point broadside. Along each side, in barbette turrets, were the 6-inch guns, shown below. These were for much closer range actions, and to be used to threaten merchant ships, which were required to be stopped to be searched for contraband that may be useful to the enemy.

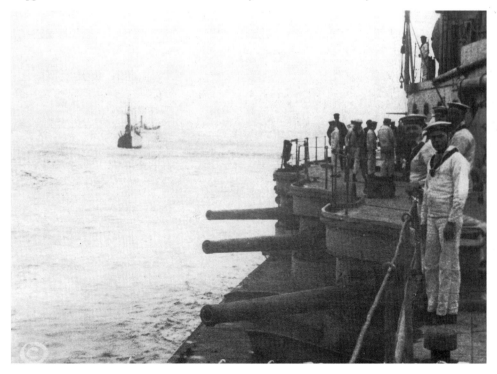

The shells from the 15-inch guns could be propelled some twelve miles, and were among the most powerful on any British warship of the war. Deadly accurate at times, they could sink a ship in one salvo. *Below:* Each ship would have at least one pet. *QE*'s pet cat, having just been thrust into the barrel to get its photo taken, is having none of it and is wandering back down the barrel in disgust.

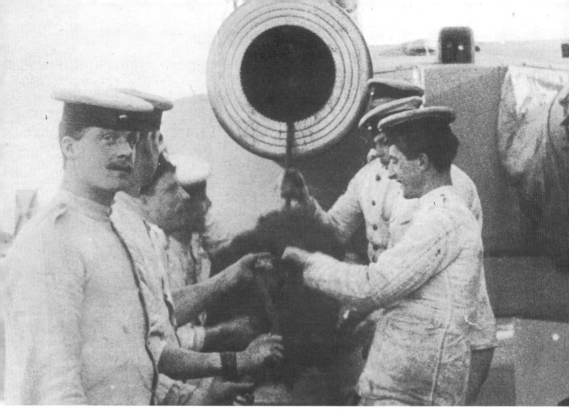

After firing, the gun barrels needed to be swabbed. Cotton was to remove the propellant from the rifled barrels and oil would protect the barrels from the ravages of the sea. Swabbing was a dirty job but one of the few left aboard ship, as coal dust was no longer an issue. *Below:* Eight or ten men were required to pull the swab through the barrel.

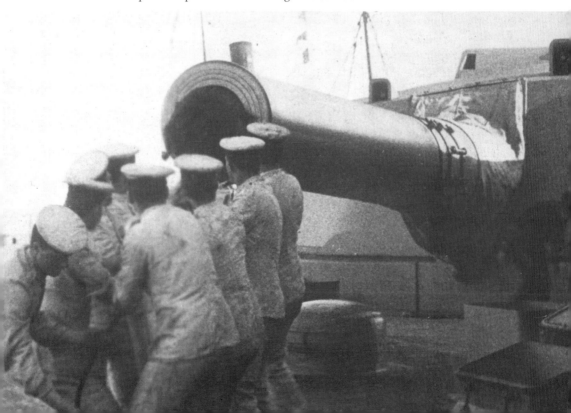

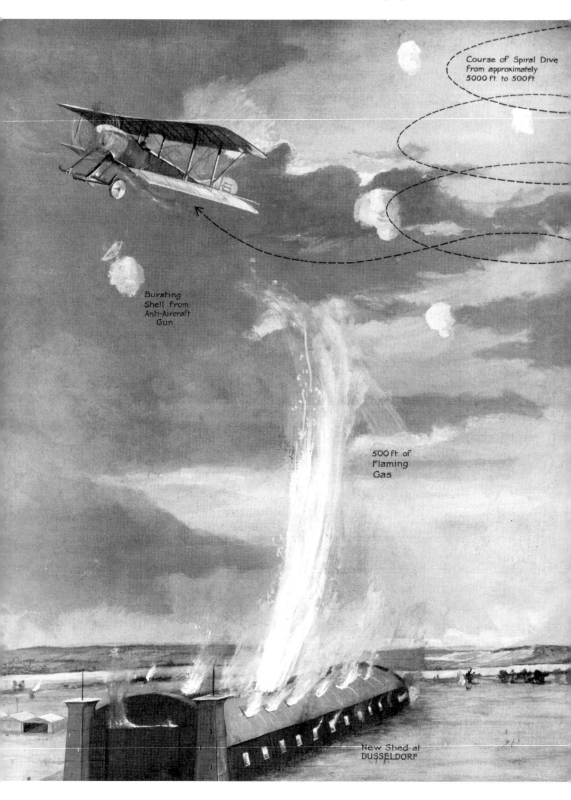

Course of Spiral Dive
from approximately
5000 ft to 500 ft

Bursting
Shell from
Anti-Aircraft
Gun

500 ft of
Flaming
Gas

New Shed at
DUSSELDORF

The Cuxhaven Raid on Christmas Day

Naval Aviation was far ahead of the army's attempts, with the Royal Naval Air Service formally created on 1 July 1914. The RNAS has a mixture of both land and sea planes at the start of the war. Training had begun in 1910, when the navy had been given two aircraft by the Royal Aero Club. At the start of the war, three cross-channel ferries and two Isle of Man steamers were converted for use as seaplane carriers, with hangars astern and cranes to lift the aircraft in and out of the water. The three cross-channel steamers undertook the raid on Cuxhaven's Zeppelin base on Christmas Day, 1914, giving the Navy an offensive air capacity.

Above: Marines aboard HMS *Dominion*, a King Edward VII-class battleship built in 1903, celebrate Christmas Day 1914. Note the Christmas pudding in the bottom right corner.

Postscript to 1914

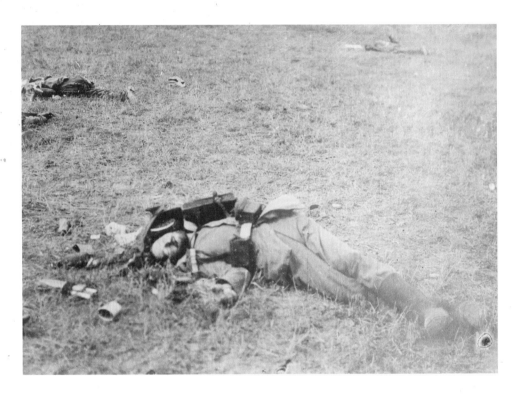

Above: The body of a German soldier on the battlefield.

At the close of the first year of the war the casualty figures had already attained staggering proportions. There were around 1 million Allied dead. Germany had suffered 675,000 casualties on the Western Front, and an estimated 275,000 on the Eastern Front. There were 1 million Austro-Hungarians dead, and 1.8 million Russians.